T0373296

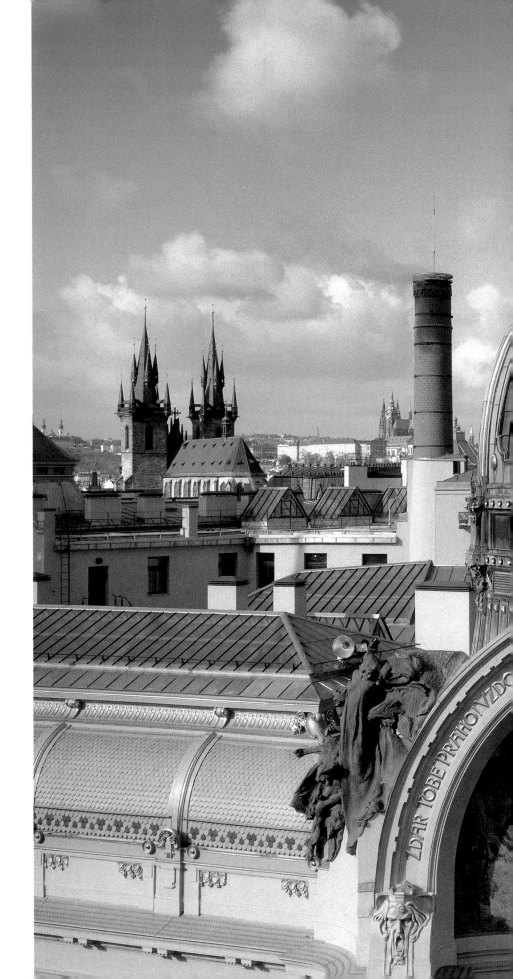

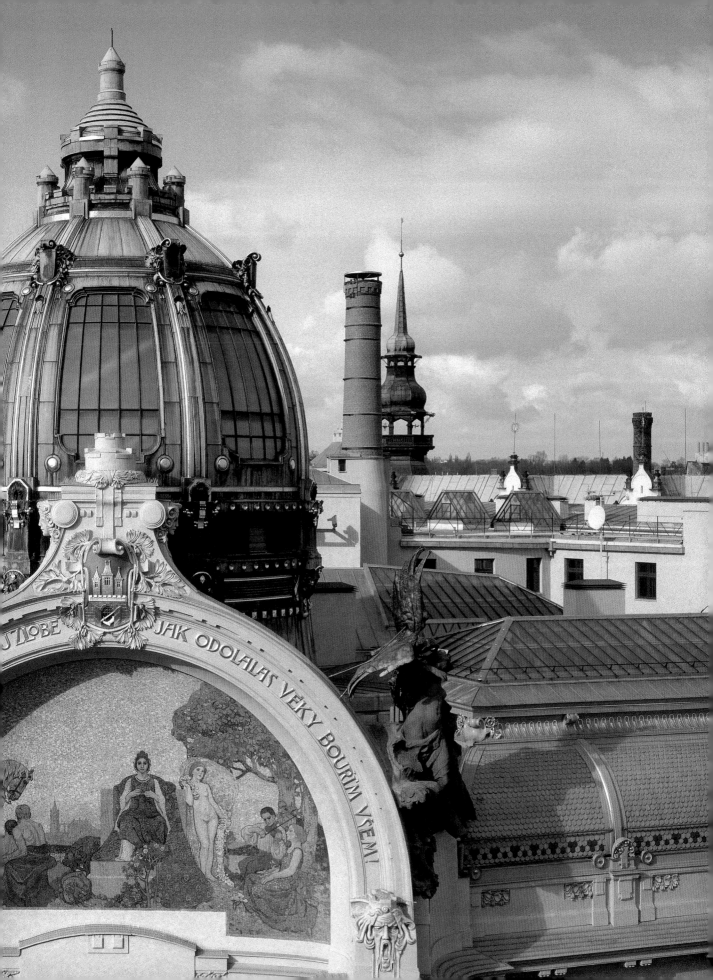

ART NOUVEAU

PRAGUE

Petr Wittlich
Photographs by Věroslav Škrabánek
Translated by Petra Key

Charles University
Karolinum Press

Originally published in Czech as *Praha secesní*, Prague: Karolinum, 2017
KAROLINUM PRESS is a publishing department of Charles University
Ovocný trh 560/5, 116 36 Prague 1, Czech Republic
www.karolinum.cz

Karolinum Press © 2020
Text © Petr Wittlich, 2009 first English edition, second, revised and updated edition 2020
Translation © Petra Key, 2020
Photography © 2020
Věroslav Škrabánek: cover, front matter, nos. 1–10A, 11–47
Archiv hlavního města Prahy, Sbírka fotografií: pp. 14, 18, 25, 28
ČTK (René Volfík): p. 22
Národní galerie v Praze: pp. 20, 21, 35, 38, 40–41
Uměleckoprůmyslové museum v Praze: p. 21; nos.: 10B–K
Západočeská galerie v Plzni: pp. 30–31
Map © Jaroslav Synek, 2020

Edited by Milada Motlová (Czech) and Martin Janeček (English; in collaboration with Julia Tatiana Bailey)
Cover and graphic design by Zdeněk Ziegler
Typeset by DTP Karolinum
Printed in the Czech Republic by Tiskárny Havlíčkův Brod, a. s.
First English edition

ISBN 978-80-246-4293-2

The manuscript was reviewed by Professor Jan Royt (Institute of Art History,
Faculty of Arts, Charles University), Dr. Mahulena Nešlehová (Institute of Art History,
The Czech Academy of Sciences)

The Prague series is edited by Milada Motlová

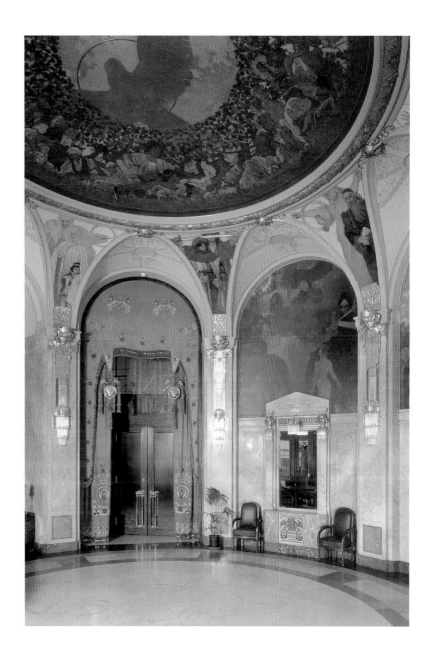

CONTENTS

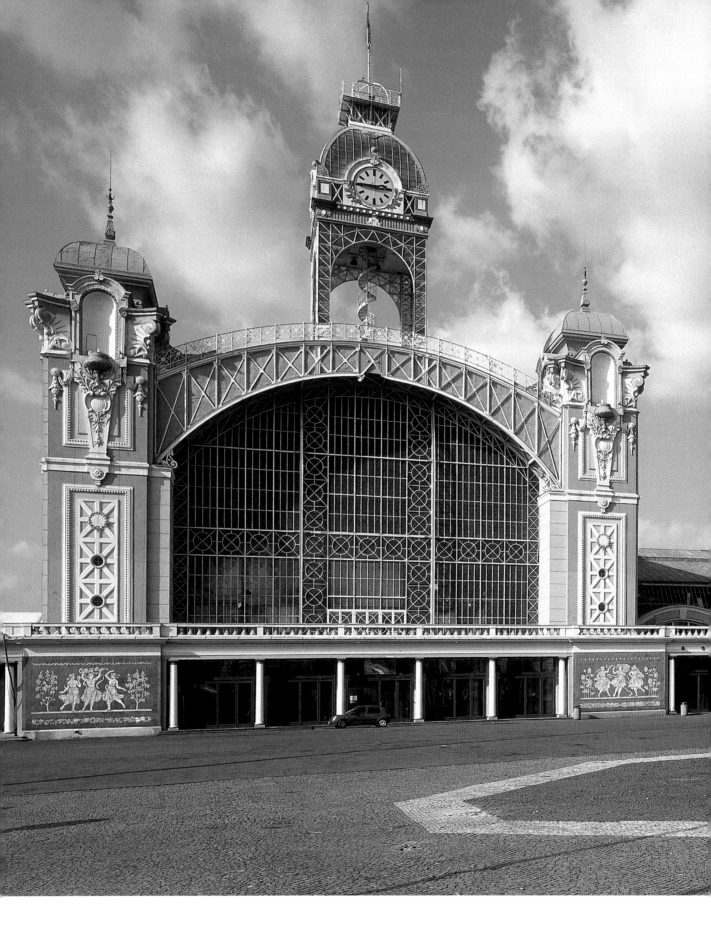

FORMS OF THE STYLE

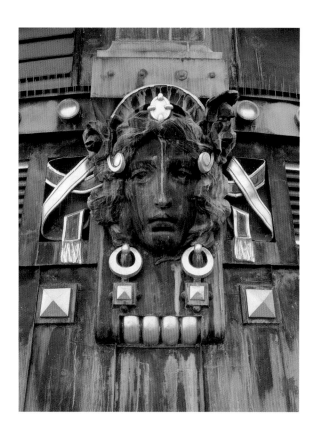

The thousand-year-old city of Prague boasts many architectural styles that have contributed to its present-day appearance, most notably Gothic and baroque. No less important, however, was the contribution of the modern age, which became an integral part without disrupting Prague's unique charm.

At the turn of the 20th century, Prague, like many other European urban centres, underwent a fundamental transformation, from a regional capital into a metropolis. The demolition of the city walls loosened the medieval constraints around the central parts of the city, leading to a rapid expansion of new suburbs, which retained their own administration for many years. The advantages offered by these independent districts attracted builders and brought about an influx of urban immigrants. Meanwhile, the city centre suffered from social tensions, largely due to the fact that Prague was again becoming a natural centre for the life and representation of the Czech nation. It was during this time that modern Czech national consciousness was reaching its peak, hand in hand with economic, political, and cultural emancipation, though still within the Austro-Hungarian Empire.

From the 1860s, Czechs dominated the Prague City Council. In the following decades, it set out to build prestigious new landmarks, while undertaking an extensive reconstruction of entire city districts, as part of a programme of urban improvement and regulated development.

In the last decades of the 19th century, ceremonial buildings such as the National Theatre and the Rudolfinum, designed by Josef Zítek, emerged on the Vltava River's right bank. The National Museum, designed by Josef Schulz, now dominated Wenceslas Square. All these buildings were designed in the Renaissance classicist style, which was considered particularly suitable for their purpose. The demand for modernity, which respected and exemplified this period of technological progress and prosperity, was first voiced during preparations for the General Land Centennial Exhibition. Held in 1891, it saw the inauguration of the large exhibition grounds in Prague-Bubeneč and marked a phenomenal manifestation of the development of the Czech element. This was also expressed through the exhibition architecture. As was common in this period, during the planning of the central Industrial Palace, architect Bedřich Münzberger changed the project and, in place of a traditional stone building, designed a glass and metal structure. It reflected current European exhibition architecture and was strongly influenced by the Paris World's Fair of 1889, an impression reinforced by the construction of a scale imitation of the Eiffel Tower, which was erected on Prague's Petřín Hill.

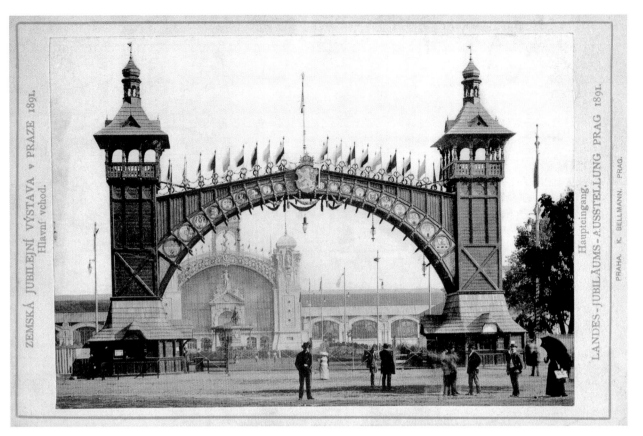

A view of the entrance gate to the exhibition grounds in Prague-Bubeneč during the General Land Centennial Exhibition in 1891

It represented an artistic fusion of the folklore-inspired watchtowers, popular in the period, with the modern construction of the arch. It remained in place until 1952.

Thanks to the technical innovations of the era, the Industrial Palace reached a remarkable size and its spaciousness had a pleasing aesthetic effect on visitors. Bridge steel, which replaced the cast iron that had been used up until this point, became a popular material. Structuralist or "engineered" architecture, whose main proponent was Hubert Gordon Schauer, often appeared where there was a need to create a large inner space, such as in Prague's city marketplace, designed by Jindřich Fialka and built between 1893 and 1896.

At the same time, most of the pavilions and exhibition halls at the General Land Centennial Exhibition were still constructed in various historical styles. The Hanau Pavilion, designed by the architect Otto Hieser, was a particularly distinctive example, entirely constructed from products of the Hanau steelworks and shaped to imitate the repertoire of the Renaissance. This was a typical example of "late historicism," in which the designer intended to produce a picturesque whole by borrowing freely from all the historical morphology known to a Renaissance man of the 19th century.

When comparing the National Museum and the Industrial Palace, two large buildings erected in Prague around 1890, we can observe the interesting polarity in the mentality of the period, expressed through different technological methods and varied forms, even while they share the same compositional design. Both

have a large central pavilion, topped with a dome, and side wings. In the case of the Industrial Palace, these wings were designed to be changeable, depending on the size of the exhibition. The centre of the National Museum, on the other hand, is bisected by a central staircase, with a pantheon of statues of famous Czechs and allegorical murals depicting national mythical themes. Surmounting the Industrial Palace, whose exterior was originally also adorned with statues and a historical portal, there is a filigree-inspired spiral staircase leading to the clock, above which the Bohemian crown of St. Wenceslas was placed.

At that time, the National Museum and the Industrial Palace were situated on opposite sides of the royal city of Prague. However, from the 1880s, the idea of connecting the spacious northern parts of the city with its centre was germinating in the minds of those who supported Prague's modernisation. This idea led to the concept of creating a wide city boulevard, linking Wenceslas Square with the Old Town Square, then continuing to the Vltava River and across the new Svatopluk Čech Bridge to the Letná and Bubeneč suburbs. As the Vltava was a busy commercial and supply thoroughfare in those days, there were also plans for a new port.

This concept was related to a proposal for a large-scale redevelopment of the area between the Old Town Square and the river. This area used to be the site of a Jewish ghetto, which legally ceased to exist in the middle of the 19th century, after which its buildings became a haven for Prague's poor. The City Council's sanitation arguments accelerated the plan, leading to the enactment of a new building code and the announcement of a competition for the city redevelopment in 1886.

The winning project was designed by the chief city geometrician, Alfréd Hurtig, and engineers Štrunc and Hejna. The imperial decree authorising the redevelopment law, not issued until 1893, opened the way for the area's reconstruction, which continued from the mid-1890s until the end of World War I.

To understand this project's massive impact on city life, we have to appreciate its scale, which required the demolition of about six hundred buildings. This transformation also included the installation of pressurised water piping and the construction of an impressive new sewerage system, designed by English engineer W. H. Lindley. Even today, one can admire the confluence of the main sewers, situated somewhat paradoxically close to the City Hall, and the modern character of the sewage processing plant in Prague-Troja, built by a specialised Italian company.

The reality of the slum clearance was so shockingly dramatic that it soon provoked fierce disagreement not only among the general public, but also among experts. Prague's redevelopment undoubtedly drew inspiration from the bold, urbanistic project of Paris, designed by Baron Haussman, and from the Viennese Ringstrasse. In Prague, however, it was met with strong opposition by defenders of the traditional character of the city.

As early as 1895, the Architect and Engineer Club and the Artistic Association both issued a statement against the slum clearance, in reaction to the beginning of the demolition of buildings on the northern side of the Old Town Square. Several valuable monuments in this part of the square were sacrificed, which

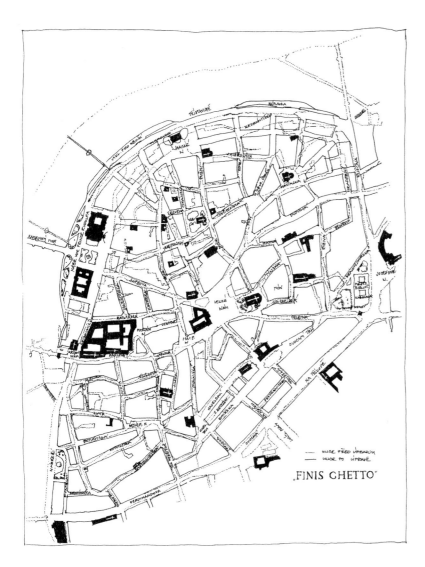

"FINIS GHETTO"

Finis Ghetto, a competition project for a large-scale redevelopment of Prague's Old Town and Josefov, 1887

The winning project in the competition, announced in 1887 by the Council of the Royal Capital City Prague, was designed by the city geometrician, Alfréd Hurtig, and engineers Alfréd Štrunc and Jan Hejna. It approached the urban redevelopment in a relatively respectful way, focusing on straightening the existing traditional communication routes. The most radical changes were implemented in the area of the former Jewish ghetto and Josefov, where the plan introduced essential requirements for the improvement of the city through the construction of new apartment buildings, divided by sufficiently wide streets.

compounded earlier losses, such as the Melantrich House and the Krocín Fountain. The memorandum was soon followed by the Easter Manifesto of the Czech People, signed by a number of eminent representatives of Czech culture, and by a pamphlet – "Bestia Triumphans" – by writer Vilém Mrštík. This resistance to the slum clearance culminated in the establishment of the Club for Old Prague, which subsequently monitored the progress of the redevelopment with a critical eye, while applying the principles of modern monument preservation that were being formulated at the same time.

When the reconstruction project was extended to the New Town, it was public resistance that saved several endangered monuments, including a number of churches. Despite later changes made in 1902 by architect Josef Sakař, in the slum clearance area of Josefov and adjacent parts of the Old Town, the redevelopment project was carried out with the consistency considered necessary. Nevertheless, it must be noted that its authors abstained from any radical changes to this area's urban structure in terms of communication routes. In fact, they straightened and opened up roads. Thus, the main west–east route, from Dlouhá Street, across the

VILÉM MRŠTÍK: **Bestia triumphans**, cover
by Zdenka Braunerová, 1897

This activist text, written by a renowned author,
called for the "preservation of the quaint character
of Prague" and passionately protested against the
initial consequences of the large-scale demolition.
Mrštík borrowed the title from Friedrich Nietzsche,
to indicate the uncultured ignorance of those
who made decisions about the redevelopment,
including the destruction of old monuments.
The cover, by painter Zdenka Braunerová, depicts
an idyllic neighbourhood in Prague, over which
ominous clouds are gathering.

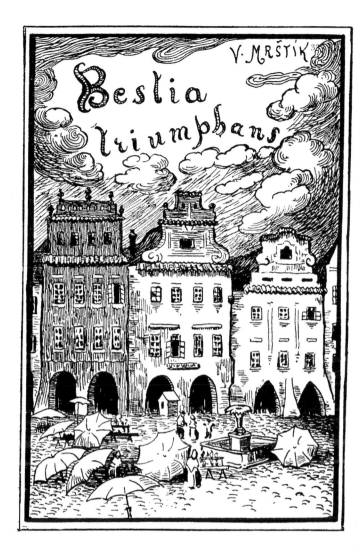

Old Town Square, along Kaprova Street to the square in front of the Rudolfinum,
where it was planned to cross the new Klárov bridge, was essentially preserved.
This route had served as a conduit since medieval times and it followed an ancient
trade path. The new housing plan respected the old street layout, while simultane-
ously asserting new path widths and eliminating earlier and often rather chaotic
clusters of low buildings.

The most radical act was clearing space for the 24-metre wide Mikulášská
Avenue (today known as Pařížská Avenue), leading directly northwards from the
Old Town Square to the Vltava River. To make room for its entrance to the Old
Town Square, the Krenn House, which obscured the view of St. Nicholas' Church
in the north-western corner of the square, had to be torn down. Mikulášská
Avenue was to be the symbol of an expanding modern city. At its other end,
Svatopluk Čech Bridge was built from 1904 to 1906, according to a design by
architect Jan Koula and engineer Jiří Soukup.

Further development of the open areas of Letná and Bubeneč was hindered
by the steep gradient of the left river bank. In the 1890s, a trench or a tun-

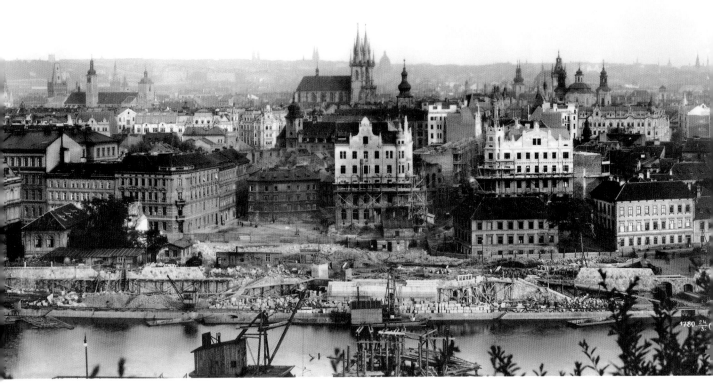

A panoramic view from Letná Park of the Old Town and Josefov during the large-scale redevelopment, 24 May 1906

This photograph gives an idea of the extraordinary scale of Prague's redevelopment. This project, organised to facilitate the city's improvement and modernisation, began in the mid-1890s and affected an area of more than 350 square metres in the Old Town and Josefov.

nel was considered, though the project competition was not announced until 1909–1910. The competition did inspire some interesting solutions; yet, unlike a similar problem in the south of the city – the Vyšehrad rock, which was tunnelled through in 1903–1905 – work was not carried out until well after World War I. This was probably due to the fact that, in the meantime, the overall city structure of Prague, as the capital of the Czechoslovak Republic, had changed considerably.

Though the period of slum clearance had set two implacable groups – modernists and antiquarians – against each other from the outset, it also prompted the search for a solution that would allow for the coexistence of both standpoints. Already during the demolition of the houses on the northern side of the Old Town Square, which stopped short of the ancient building of the Paulist monastery, a compromise was reached to allow the corner building to use mainly baroque decorative features. Designed by Rudolf Kříženecký and originally including a corner turret, this façade was similar to the much more interesting City Insurance Bank by Osvald Polívka. The latter even segmented his richly sculpted and colourful façades into two bays, to preserve the illusion of the original rhythm of

the street frontage. Meanwhile, the iconography of the decorative sculptures on Kříženecký's house directly reflected the topicality of the era's primary conflict.

In the 1890s, the neo-baroque spread through Prague rapidly, even though not long before it had been considered a style in decline. It suited not only the integration of the mass of new buildings into the exterior spaces of Prague, where the historical baroque had left so many traces, but it also liberated the artistic expression of the architects, and thus could be regarded as something modern. This trend is reflected in the sudden shift from the use of original baroque forms and shapes (the Valter Palace by Friedrich Ohmann, 1891–1892, and the large complex of the Straka Academy by Václav Roštlapil, 1892–1897) to the heightened artistry of later designs (Ohmann's interior of the Variety Theatre, completed between 1896 and 1898).

Although the neo-baroque provided the architect with an overall idea and offered methods for expressing its dynamic form, we can see that the architectural imagination at the end of the 19th century was still strongly influenced by the habit of combining various stylistic forms in a cumulative way. This custom of amalgamating a variety of decorative and stylistic motifs, especially on a building's façade, was later criticised as inartistic and, indeed, on many occasions exceeded the bounds of acceptability. On the other hand, this also gave rise to the characteristic collages, which are interesting not only from an iconographic perspective. Late historicism often progressed in this way, while its shapes bore witness to a new sense of the decorative whole.

This development can be seen in the bourgeois houses with painted façades, so popular in the 1890s. Antonín Wiehl's own house on Wenceslas Square (1895–1896), with historical-allegorical paintings by Mikoláš Aleš and Josef Fanta, still upholds the stylistic principles of what became known as the Czech Renaissance, which Wiehl himself had pioneered. Friedrich Ohmann, in designing the house U České orlice (Bohemian Eagle House, 1897), and particularly its façade facing Ovocný trh, had already abandoned the hitherto obligatory orthogonal decorative scheme in favour of a free composition of motifs, which respects the wall surface and leaves part of it free of decoration.

In the second half of the 1890s, calls for a new, modern decorative style grew stronger, in spite of Prague's rather conservative atmosphere. This was often expressed in the form of caricature, as in the case of the popular public house U Nesmysla, designed by Jan Koula for the Exhibition of Architecture and Engineering, which was held at the Prague exhibition grounds in Bubeneč in 1898. However, it was not long before the problem manifested through this grotesque style had to be taken seriously: not only because it faced foreign challengers representing new architecture, of which the Czechs were most impressed by Wagner's tram stops on Vienna's Ringstrasse; but also because of pressure exerted by the young generation of artists. In 1898, this generation entered the public eye for the first time with group exhibitions by members of the Mánes Association of Fine Artists.

Volné směry (*The Free Trends*), an arts periodical published from 1896 by the Mánes Association, reported on European events and started to openly promote

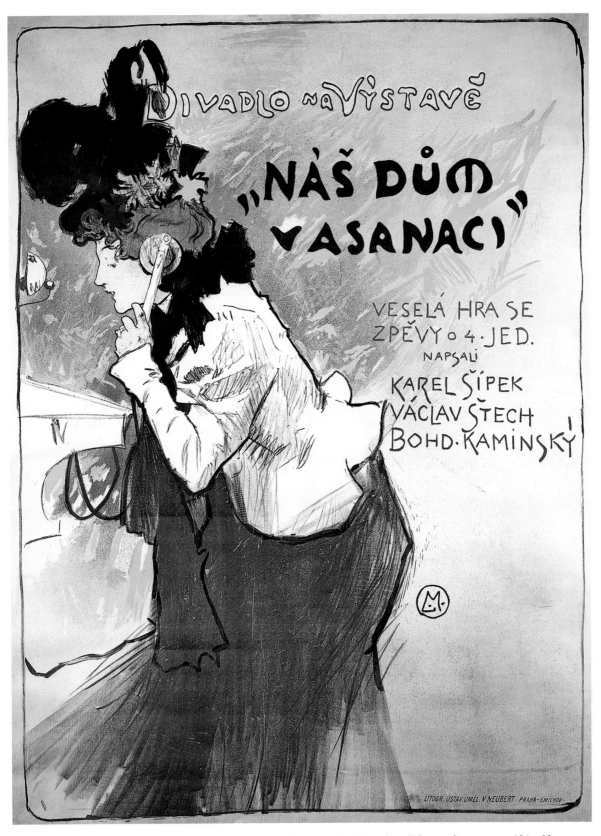

LUDĚK MAROLD: **Poster for "Our House under Redevelopment,"** 1898, colour lithograph on paper, 124 × 92 cm, Museum of Decorative Arts in Prague

This poster promoted a theatrical production on the topical subject of the redevelopment of Prague, which was staged at the Exhibition of Architecture and Engineering at the exhibition grounds in Prague-Bubeneč in 1898. Marold, an outstanding illustrator of subjects from daily life, stylised his customary naturalism in a "Japonist" manner, following the French masters of this modern genre.

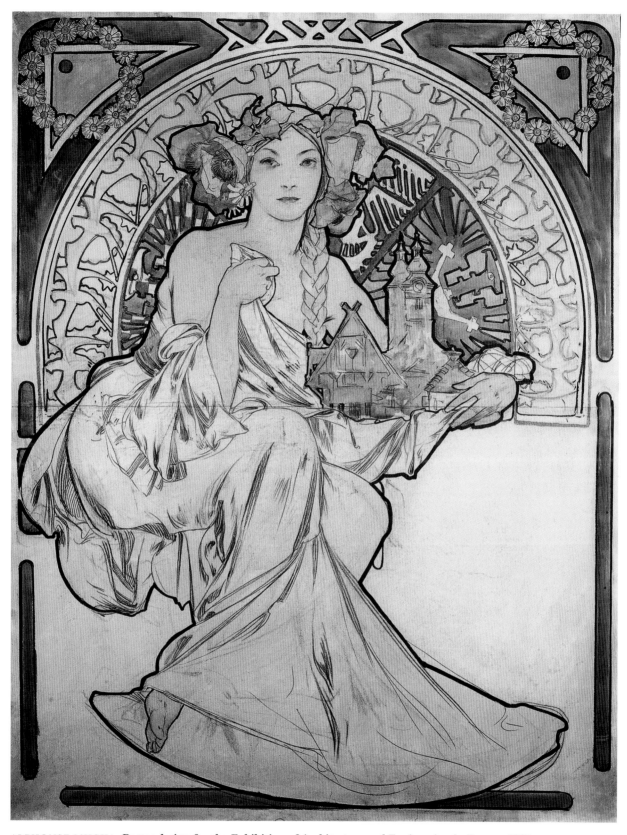

ALPHONSE MUCHA: **Poster design for the Exhibition of Architecture and Engineering in Prague**, 1897, charcoal and watercolour on paper, 108 × 85 cm, National Gallery Prague

Mucha's design represents an allegorical figure of Czech architecture holding a rural log house and a baroque church as its attributes. Despite only winning second prize, this design – along with Mucha's other works exhibited in Prague in 1897 – in fact significantly influenced Czech acceptance of the Art Nouveau style. The decorative composition of the female figure and ornamental frame already has all the hallmarks of the mature style.

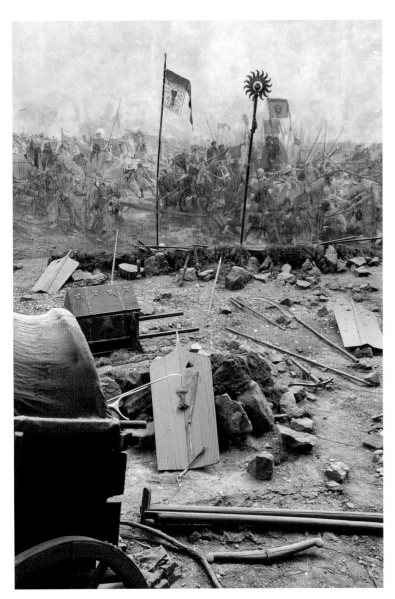

Panorama of the Battle of Lipany

Luděk Marold and his assistants painted
a circular panorama of the Battle of Lipany as
an attraction at the Exhibition of Architecture
and Engineering, held at Prague's exhibition
grounds in 1898. It depicts the final stage
of the 1434 battle, which is infamous as a
fratricidal fight among Czechs. With the help
of landscape painter Václav Jansa and other
assistants, Marold covered a huge canvas
measuring 11 by 95 metres in the record time
of four months. This was only made possible
through the use of the illusionistic painting
technique that he learnt in Munich and Paris.
Scenographer Karel Štapfer accentuated the
painting's sense of illusion with a veristic
augmentation in the foreground. At the time
of its creation, Marold's panorama was
considered the height of modernity.

the new decorative style, which was triumphantly marching from its Belgian-
French epicentres.

At the turn of the century, Art Nouveau met with a strong reaction in the
Czech lands. The Prague exhibition of graphic artworks by Alphonse Mucha
in 1897 was an important event in this respect, as it presented the Art Nouveau
idiom as a mature decorative system. For the Exhibition of Architecture and En-
gineering, Mucha designed a poster typical for the style, in which the allegorical
figure of architecture holds models of a baroque church and a Czech cottage as
its attributes. Even though this poster was ultimately not used to promote the
exhibition, it marks the beginning of the remarkable development of the Czech
poster, which became a direct model for the union of modern art and life. The
new aesthetics of the poster – assuming the piece to be a decorative whole – be-
came a style icon, with its influence even extending to architecture. It was from
the poster that both individual motifs (notably floral patterns and new types of

mascarons) and the general concept of decoration, especially colours, were transferred to the Art Nouveau house elevations. Indeed, some elevations by Osvald Polívka look like posters (Praha Insurance Company, 1906–1907).

The School of Decorative Arts, founded in 1885, became an important institution in Prague and proceeded to spread this new style. At its conception, it embraced the then-current principle of stylistic pluralism, but it quickly changed course in favour of Art Nouveau in the second half of the 1890s. This change was partly due to the task of presenting the school's works at the Paris World's Fair in 1900, and partly due to the initiative of individual professors. Celda Klouček, head of the decorative sculpture studio, initiated a large set of ornamental vases in the style, which won a prize at the Paris exhibition. Along with the poster, ceramics became another key example of the application of Art Nouveau, this time in three dimensions. As such, the style also became a source of creativity and craftsmanship, which later extended to construction and design practice, thanks to graduates of the School of Decorative Arts and other trade and craft schools. This was how Art Nouveau quickly proliferated in the Czech lands as a symbol of modernism and for several years dominated production. The rapid

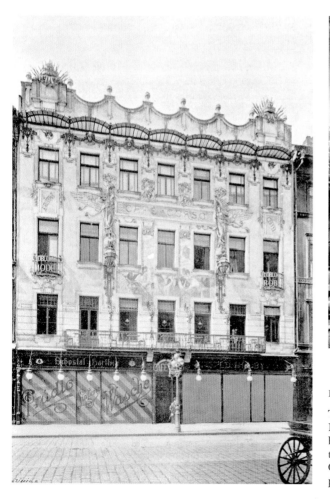

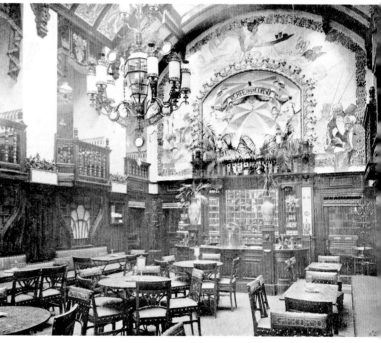

FRIEDRICH OHMANN: **Corso Café**, 1898, exterior and interior

The Corso Café was a typical predecessor to the application of the Art Nouveau style. The new aesthetics was represented on the front façade by the main cornice with glass panes, projected from the building in the style of an Art-Nouveau "awning," and by simple motifs in Viktor Oliva's paintings. The picturesque interior of the café, with its wooden panelling, likely had a more modern feel.

pace of construction, both in Prague and other Czech cities, ensured that the style gained an aesthetic legitimacy, which guaranteed the smooth linking of calls for modernism and demands for the continuation of tradition. It was in this manner that Art Nouveau transformed, rather than broke with, older foundations.

In 1898, Celda Klouček applied new floral decorations on the Wohanka House in Dlouhá Street, whose finely sculpted figural portal is a good example of his inspiration by the forms of the Italian quattrocento. A true hallmark of his skill is undoubtedly the decoration of the Prague Credit Bank, built by architect Matěj Blecha in 1902, on which the overall repertoire of Art Nouveau decorative forms was precisely executed in stone and completed by inscribed bronze bands.

Another professor of the School of Decorative Arts, Friedrich Ohmann, looked to the new decorative style when designing the Corso Café (1897), which has

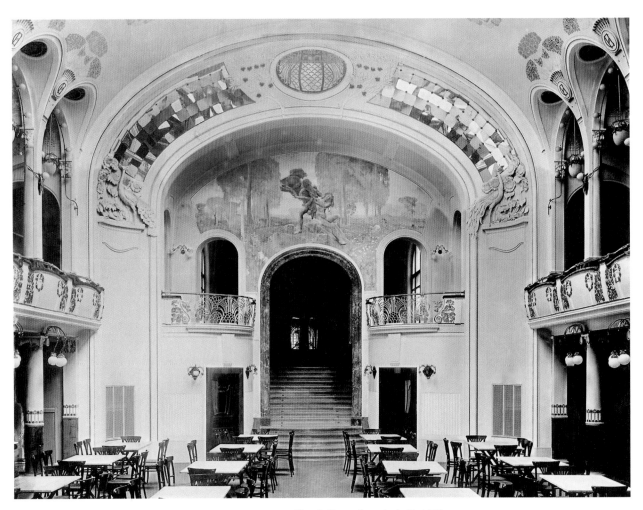

FRIEDRICH OHMANN: **Hotel Central**, main hall, 1902

The main hall of this hotel, the first to be built in Prague in the Art Nouveau style, was adorned with murals by Karel Špillar and Jan Preisler and with sculpted decorations by Ladislav Šaloun. It was the venue for significant events, including the official lunch in honour of August Rodin's visit to Prague in 1902, organised by the City Municipality and art associations.

A view of the main façade of the Archduke Stephen Hotel on Wenceslas Square in Prague, after 1905

In addition to apartment blocks, Art Nouveau was also a popular style for community buildings. Similarly to the Hotel Central, the Archduke Stephen Hotel was a luxurious modern hotel in Prague, boasting a prominent location on Wenceslas Square.

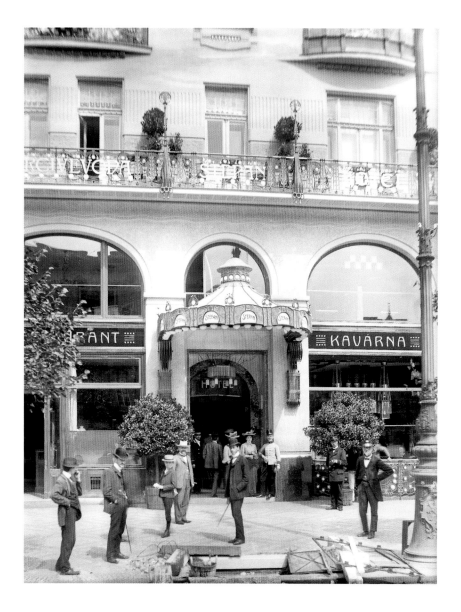

not been preserved. A true manifesto of the new style in Prague was Ohmann's scheme for the Hotel Central's façade (1898), where he fully acknowledged the basic wall surface, on which he developed floral stucco decor, suggesting the symbolism of the tree of life. His mascaron presents the Orphean theme so typical of symbolist poetry, while the gilded decorative details indicate Ohmann's Viennese orientation. When Ohmann left for Vienna, where he became a professor at the Academy, it was his students Bedřich Bendelmayer and Alois Dryák who completed construction of the Hotel Central. The building became a busy modern centre thanks to its remarkable community hall, which was the venue of the memorable banquet to celebrate the French sculptor Auguste Rodin, during his visit to Prague in 1902. Sadly, the hall was destroyed during the later reconstruction of the hotel.

The activities of Ohmann's students, among them Jiří Justich, in the first decade of the 20th century, saw several excellent achievements. In 1903, Bedřich Bendelmayer designed twin apartment buildings opposite the Powder Tower and

on the corner of Celetná Street. These represent some of the best Art Nouveau accomplishments thanks to their general plan, the combination of metal and stucco decorations, and glassed-in studios in the mansard roofs. However, it is his design for the Hotel Arcivévoda Štepán (Archduke Stephen Hotel), later the Hotel Evropa, built in 1903–1904 on Wenceslas Square, that is considered his most successful Art Nouveau achievement.

Adjacent to this prestigious enterprise, though on a much narrower lot, the Hotel Garni (Meran) was built according to the design of Alois Dryák. The two buildings create an interesting compositional formation, which, in their basic asymmetry of materials, bear witness to Art Nouveau's unique appreciation for the dynamics and gradation of forms. The decorations of both buildings, however, share the same principles and their penchant for spirals and classical festoons and wreaths makes them typical examples of the architects' Viennese inspiration.

Such inspiration is understandable, as Vienna was the closest large cultural centre (apart from Munich, which mainly attracted painters), and it was there that most architects received their higher education and found employment opportunities. In addition, the centralised Viennese government – most notably under Prime Minister Ernest von Koerber – supported culture and the universalist style of the Vienna secession, seeing it as a means of tempering and channelling the national passions that buffeted the public sphere across the entire Austro-Hungarian Empire in the 1890s. The rebellious section of the Czech populace, however, searched for an alternative to Habsburg absolutism and found inspiration most notably in France, which was considered an appropriate counterpart, not least for its republican political system. It was not an accident that this pro-French orientation, expressed in art and architectural decoration through a more naturalist and organic feeling for shapes, was applied mainly to public buildings commissioned by the Prague City Council.

Osvald Polívka, who can be considered the leading creator of the typical Prague Art Nouveau architectural variant, had the best access to such commissions. In the second half of the 1890s, Polívka experimented with means of expression, drawing from the neo-Renaissance and neo-baroque; by the turn of the century, however, he was producing most of his works in the Art Nouveau style. This was mainly evident in the modernisation of decorative motifs, enriched by organic floral elements, but also included an inclination towards the grotesque and the intensification of façade colours. Polívka's fondness for rich decoration provided painters and sculptors with many opportunities, although he was the author of the decorative plan of both building exteriors and interiors and he also designed the stucco ornamentation. Nevertheless, where the freer composition of statues or paintings (usually as mosaics) were involved, he respected the creative expression of artists invited to cooperate on the decorations, such as painters Jan Preisler and Karel Špillar, and sculptors Ladislav Šaloun, Stanislav Sucharda, Josef Mařatka, and Karel Novák, among many others.

Polívka designed Art Nouveau buildings on Haštalská Street and, in 1902, was put in charge of the reconstruction of the department store U Nováků on Vodičkova Street. The coloured fairy-tale motifs on the main elevation, unusually

rich wrought-iron decorations, and vibrant stained-glass plates on the entrance doors, make it evident that Polívka had given Prague its most attractive version of this modern architectural style.

It was a common characteristic of this period that much attention was paid to architectural ventures that used to be considered merely commercial, trying to give them the mark of modernity through the new decorative style and thus emphasise their contemporaneity. Prague sought examples from the large department stores of Paris and Brussels where, similarly, emphasis was placed not only on an attractive façade, but also on the interior plan, which favoured large halls, constructed from steel elements. Unfortunately, these impressive halls were later converted in various ways, and few have survived in their original form. Such was the case of Polívka's U Nováků department store, whose sales hall was later rebuilt into a variety theatre.

The concept of the Art Nouveau style proved eminently suitable for all functions that emerged as Prague took its place among European metropolises, meeting the requirements of modern urban life, as well as demands for a new level of luxury. Art Nouveau easily accommodated the variability of these tasks, leading the idea of their proliferation to be favoured along with the creation of new city landmarks.

In 1900, a competition was held for the rebuilding of Prague's main railway station – Franz Joseph I Station, later Wilson Station. The winner was Josef Fanta, a graduate from the Technical University in Prague, who was at that time one of the representatives of Czech decorative art at the Paris World's Fair. This large structure, built in 1901–1909, is of note mainly thanks to its central pavilion, based on the motif of a gate which is formed by a large thermal window and serried between two high pylon towers. The decoration of the imposingly vaulted entrance hall inside the pavilion, designed down to the last detail by Fanta himself, is an excellent example of the Czech Art Nouveau style. The rich sculptural decoration of the exterior is also typical, especially the towers, which were contributed to by leading Czech sculptors such as Ladislav Šaloun, Stanislav Sucharda, and Čeněk Vosmík. Another standard feature of the style is the interconnection of this decorative building with the markedly technical element of the steel structures covering the platforms. The blending of decoration and structure expresses the play of female and male qualities, an idea that the Art Nouveau period imagination found highly attractive.

Another prominent architectural landmark in this new Prague was the Municipal House, designed as a status symbol for the Czech majority. Even the location of the building within Prague's urban plan was considered important: it was positioned on the former site of the Royal Court of the Middle Ages – the seat of many Bohemian kings. In later eras, St. Adalbert's Church and a military academy were also situated there. The Powder Tower has been standing next to this piece of land since the 15th century, serving as the ceremonial entrance to the Old Town, and the starting point for both coronation and funeral processions of Bohemian kings. In the 1880s, the Powder Tower underwent an expensive reconstruction and re-Gothicisation by architect Josef Mocker.

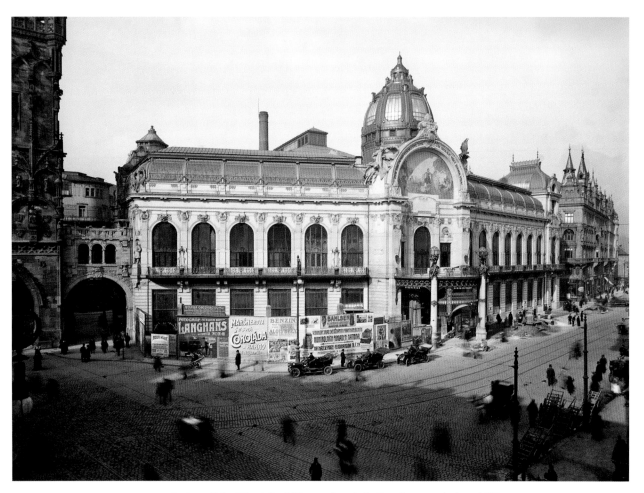

A view of the Municipal House shortly before its completion, 1911

The construction of the Municipal House was the pinnacle of Prague's representation as the capital of the Bohemian Kingdom before World War I. This large building, whose construction commenced in 1905, passed the final structural inspection on 22 November 1912.

In 1901, the Czech Burghers' Club urged the township of Prague to permit the construction of a new building with large assembly rooms for its members. Taking advantage of the fact that the lot of the former Royal Court was vacant, the City Council generously announced a competition for the Municipal House project in 1903. When this competition failed to produce the expected result, the City Council decided to award the building project directly to architects Antonín Balšánek and Osvald Polívka. After difficult negotiations regarding the composition of the building (there was an alternative design for a Czech theatre building), the final project was approved at the end of 1904 and construction started the following year. Its ceremonial public opening took place at the beginning of 1912.

From an architectural point of view, the Municipal House is notable for its layout, in which the varied and, indeed, inconsistent programmatic demands were successfully united as a coherent whole with the monumental space of Smetana Concert Hall at the centre. This harmony is further aided by the building's external appearance, which offers an intriguing stylistic variation on the popular

plan of new public buildings in Prague: a domed central pavilion and side wings. Debate about the individual contribution of each architect is ongoing, yet in any case they managed to create a harmonious whole. They gave their motifs, baroque in essence, an organic fullness and rhythmic balanced proportions that might be perceived as in the spirit of the natural entelechies that so significantly inspired Art Nouveau. This tendency is even more apparent in the lavish decoration of the building, especially the stucco ornamentation and metalwork that dominate the beautiful marquee of the main entrance; but also in the interiors – on the ceremonial stairways and in other placcs – which bear all the hallmarks of the new decorative style in their undulating floral forms.

Alongside a vast army of craftsmen and artisans, many prominent Czech artists participated in the building's decoration. The mosaic over the main entrance, entitled the "Apotheosis of Prague," was created by painter Karel Špillar, whose poetic allegories also ornament the ceiling and walls of Smetana Hall. The contributors to the decoration of the prestigious halls of the ceremonial first floor include Max Švabinský, with his group portraits of Czech writers, musicians, and artists in Rieger Hall; Jan Preisler, whose large decorative panel paintings in Palacký Hall illustrate the theme of the Golden Age; and František Ženíšek, whose romantic compositions light up Grégr Hall. Ladislav Šaloun and decorator Karel Novák were the most outstanding contributing sculptors.

Although the decoration of the central Mayor's Hall was hotly debated at the time, it is undeniably the most impressive work of the entire Municipal House. Created by the famous Alphonse Mucha after his final homecoming in 1910, this expression of the artist's impassioned appeal for national consciousness was nonetheless the last important interior executed in true Art Nouveau decorative style. Once more, the artist took up the task of designing all details of a homogeneously composed interior: from murals, stained-glass windows, and furniture, to the richly embroidered drapes and metal fittings. The orange, black, and blue colour scheme gives this room a feeling of ceremonial seriousness, and yet also one of emotional warmth.

The controversy surrounding the assignment of this work was symptomatic of the schism that divided artistic thought in Prague at the time. The artistic community was split both on a generational level and, deeper still, on an ideological one. A large group of artists and theoreticians had formed around the Mánes Association of Fine Artists, who sought a different orientation and often made use of new tendencies then emanating from Vienna. A trend for stylistic purism soon appeared and was most clearly expressed in architecture. It greatly suppressed the earlier naturalistic tendencies and set new norms, mainly in the fields of decoration and ornamentation. Unlike the earlier organic feeling for form, the new trend tended towards geometric and strongly stylised elements.

This new aesthetic was typified in Otto Wagner's Viennese school of architecture, where many Czechs studied. The first of them was Jan Kotěra, who became a professor at Prague's School of Decorative Arts when he was only 27 years old.

Kotěra's first important achievement was the Peterka House on Wenceslas Square, built in 1900, which clearly shows the determination to moderate decora-

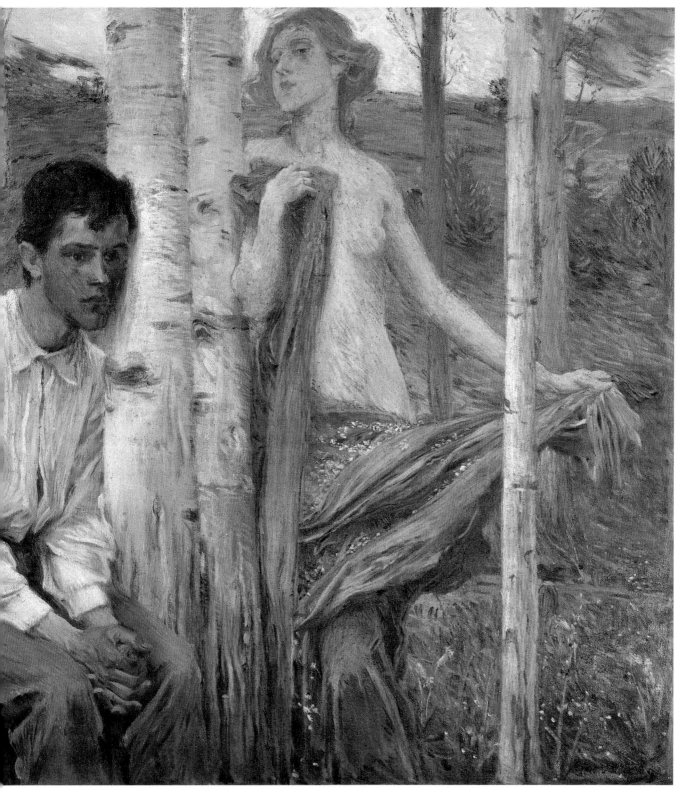

JAN PREISLER: **Spring** (centre panel), 1900, oil on canvas, 112 × 70 cm, 112 × 186 cm, 112 × 70 cm, Gallery of West Bohemia in Pilsen

Preisler's triptych *Spring* – commissioned for the Urbánek House and exhibited at the 3ʳᵈ Exhibition of the Mánes Association of Fine Artists in Prague in 1901, where it received a very positive response – represented a turn from naturalist illusionism to the post-impressionist style. In this painting, Preisler demonstrated both the outstanding lyrical qualities of his talent and his feeling for stylistic decoration in harmony with Kotěra's Art Nouveau architecture.

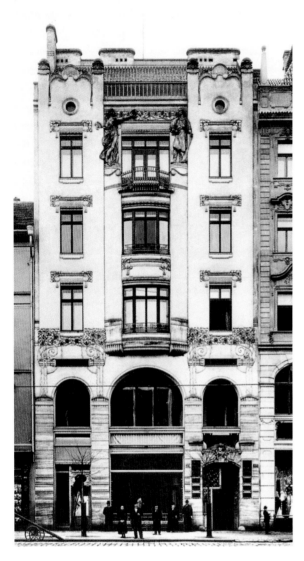

JAN KOTĚRA: **Peterka House** (Wenceslas Square 12)

The Peterka House on Wenceslas Square, designed by Jan Kotěra in 1899, is one of the earliest examples of the Art Nouveau style. Kotěra was then the youngest professor at the School of Decorative Arts. He gained his architectural schooling in Vienna, under Otto Wagner, which is reflected in the serenity of the main façade and in the ornament gilding. The building's proportions are almost gothically lyrical. Kotěra astonished Prague's inhabitants with the unusual width of the shop window and an exposed iron girder under the central oriel. The interior was decorated with Jan Preisler's memorable triptych, *Spring*, which signalled a turn towards modernity in Czech painting.

tion, as well as a sense of purity in the overall composition, both typical features of Kotěra's artistic expression. The modern element of a commercial half-storey was accentuated by the width of the shop windows, which was then rather extraordinary in Prague. The interior also bears witness to Kotěra's desire to create a uniformity in this new style. Jan Preisler's triptych "Spring," considered one of the first Czech modernist manifestos in painting, formed part of the interior decoration, although it is now in the Gallery of West Bohemia in Pilsen. Preisler abandoned naturalist illusionism and introduced a synthetic concept of colour distribution into the picture, symptomatic of the rise of modern aesthetics that was already evident in new posters.

Both Preisler and Kotěra were very active members of the Mánes Association of Fine Artists, where this new aesthetic was cultivated methodically and with mounting seriousness. Alongside the magazine *Free Trends*, published by the Mánes Association, the main means of dissemination were exhibitions likewise presented by this organisation, including notable displays of French art, which

was considered the best example of the genre. In 1902, a memorable exhibition of Auguste Rodin's sculptures and drawings was organised in addition to a display of French painting. Rodin's visit to Prague was the principal social event that helped to forge general acceptance and understanding of new art within the local scene. The exhibition was presented in a special pavilion designed by Jan Kotěra. Though built as a temporary structure, it was used for many other important exhibitions, and thus was instrumental in forming the fundamental profile of Czech modern art.

Modest in size and closely connected in style with Kotěra's "villa" projects in the garden suburbs of Prague (the folkloric Trmal Villa in Prague-Strašnice, 1902–1903; Sucharda Villa in Prague-Bubeneč, influenced by English models, 1904–1907), the pavilion was nonetheless executed in the lyrical spirit of the early Art Nouveau, highlighting the moment of intimacy and personal poetry. In the following years, Kotěra was given the opportunity to create large public buildings in other Czech cities (the District House in Hradec Králové, 1904; the National House with an incorporated theatre in Prostějov, 1905–1907), which introduced to his work the measure of monumentality.

The year 1908 brought about an even more radical change, which ultimately led to the true maturity of his architectural expression. In that year, Kotěra and his students contributed to another significant event organised at the Prague exhibition grounds – the Exhibition of the Chamber of Commerce and Trade – with their design for the Pavilion of Trade and Industry. With large groups of archaically stylised statues by Jan Štursa placed in the front, the elegant simplicity of its elevation was an early example of this change. Shortly after, Kotěra's shift in style was confirmed by the important new buildings of his own villa in Prague-Vinohrady (1908–1909) and, in the same quarter, a terraced house designed for the publisher Jan Laichter (1908–1909).

There were many theories about the true causes of Kotěra's aesthetic change. The sought-after exposed brickwork motifs, which began to dominate his buildings, echo the Amsterdam Stock Exchange building by Hendrik Petrus Berlage, north German medieval brick buildings, or even Frank Lloyd Wright's work, a reminder of Kotěra's visit to the United States when he was preparing the Czech exposition at the World's Fair in St. Louis in 1904. Criticism of Kotěra's early works by his Viennese teacher, Otto Wagner, might also have played a role. In fact, the cultural interconnection of Vienna with England and the USA is the most likely explanation for Kotěra's aesthetic development. Last but not least, there is the consistent adherence to the principles of a hierarchical relationship between purpose, structure, and decoration in a work of architecture, which Kotěra declared in his manifesto as early as 1900.

Some of Kotěra's students went even further. In 1909, Otakar Novotný designed a building for Jan Štenc's graphic design company in Prague's Old Town, where he managed in a very cultivated way to link aesthetic purism with the function of a modern workshop. Josef Gočár designed a similar kind of department store in Jaroměř, and his project for the new City Hall building in Prague, submitted to the competition in 1909, was a great surprise: he proposed a shock-

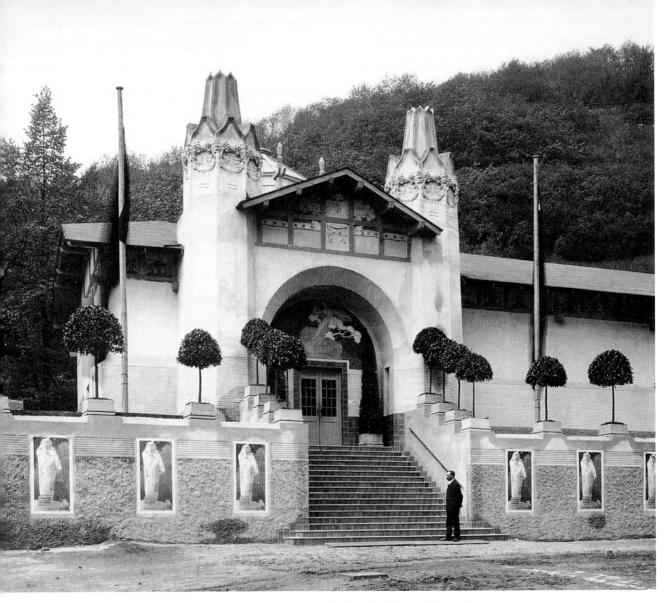

JAN KOTĚRA: **Mánes Association Pavilion**, 1902, exterior

The momentous exhibition of sculptures by French sculptor August Rodin was hosted in a wooden pavilion with a richly decorated entrance, conceived as a triumphal arch between two pylon towers, designed by Jan Kotěra especially for this occasion. The building, erected at the entrance to Kinský Garden at the foot of Petřín Hill, was used by the Mánes Association of Fine Artists as an exhibition venue up until 1917.

ing, colossal pyramid, composed of geometrical elements, as the morphological basis for a new artistic viewpoint.

This important commission was won by Osvald Polívka, who was thereby confirmed as Prague's leading architectural representative. In keeping with the times, Polívka did not repeat the Art Nouveau of the Municipal House in the new City Hall building (1909–1911). While this project does not deny the organic link and rhythm of the building materials, the decorations are nevertheless much more modest and the lines are straighter. The remarkable sculptural decoration of the main elevation, represented by quaint sculptures by Ladislav Šaloun and

JAN ŠTURSA: **Melancholic Girl**, 1906, French
sandstone, 90 cm, National Gallery Prague

Antonín Matějček wrote about Štursa's statue:
"The synthetic, succinct, firm in plasticity and supple
form embodies Štursa's idea of youth, youth that is
joyful as well as sorrowful, youth filled with hopes
and desires, but also weary from the burden of past
lives. The *Melancholic Girl* is more than a personal
expression of the artist, it is a type and symbol
of the time."

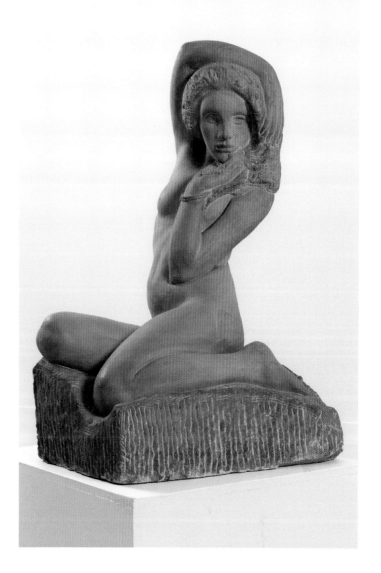

Stanislav Sucharda on one side, and neo-Grecian stylised allegories by Josef
Mařatka on the other, shows the discrepancy typical of the period: between the
dramatic rules of Rodinesque modelling; and less formally ambiguous sculpture,
influenced by the works of Antoine Bourdelle, which were first seen in Prague
at a solo exhibition presented by the Mánes Association of Fine Artists in 1909.

In 1906–1908, a purist building designed for the Viennese Bank Association
by Josef Zasche, a German architect, was erected on Na Příkopě Street. Jan
Kotěra admired its smooth granite surface. However, most Czech architects saw
it as an example of the "Germanic" style, enhanced by decorative sculptures by
Franz Metzner, whose strict expression was inspired by the Nibelungs. In any
case, it sparked an interesting discourse about Prague architecture, which once
more highlighted the question of a national, or Slavic, element. Koruna Palace,
built on the opposite corner of Wenceslas Square by Kotěra's student Antonín
Pfeiffer in 1911–1914, can be seen as a polemic against Zasche, which is most

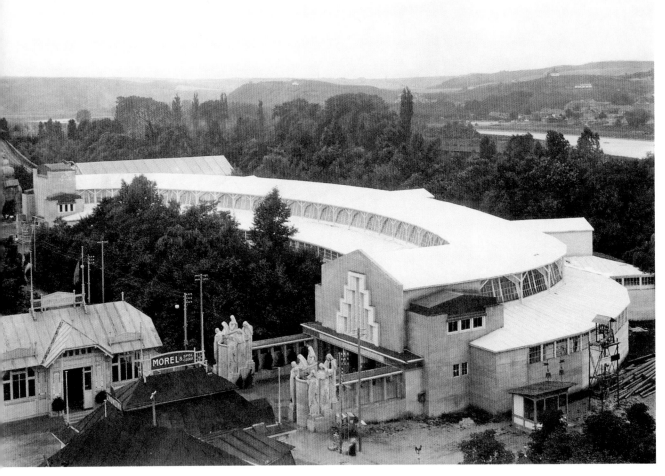

JAN KOTĚRA – PAVEL JANÁK – JOSEF GOČÁR – JAN ŠTURSA: **Pavilion of Trade and Industry at the Exhibition of the Chamber of Commerce and Trade in Prague**, 1907–1908, aerial view

Jan Kotěra and his young collaborators designed this exhibition pavilion to consist of three segmented, arched naves, with the main entrance decorated by large, archaising sculptural groups by Jan Štursa. Both the architecture and statuary heralded the evolution toward the geometrical, pure form of the style which would assert itself in the following years in Prague.

obviously expressed through its decorative ornamentation. The lyrical character of the statues of guards, sculpted by Stanislav and Vojtěch Sucharda and placed on the Koruna spire, acts as a clear counterpoint to Metzner's statues, despite the figures also being stylised to suit the rule of adjustment to the architectural geometry.

Nationalist concerns, which continued to play a political role, were manifested through cultural events, such as the unveiling in 1912 of Stanislav Sucharda's ambitious monument in Palacký Square to the historian and "Father of the Nation," František Palacký. Another large nationally motivated Czech monument, this time to Master Jan Hus and sculpted by Ladislav Šaloun, was quietly unveiled in the Old Town Square in 1915, during World War I. The character of pre-war Prague architecture was already almost universally modernist, thanks mainly to the younger generation of architects who frequently studied abroad, especially in Vienna. Around 1910, a new wave of Otto Wagner's students appeared. Of

them, Bohumil Hypšman aroused the greatest attention through his design for the food industry pavilion at the Exhibition of the Chamber of Commerce and Trade in 1908. At the same time, another of Wagner's students, Antonín Engel, won the competition for the portal of the tunnel which was to lead from Svatopluk Čech Bridge to Letná. In the end, his design was not constructed, as it was considered too Viennese. However, the plan was for it to be dominated by a large sculpture of the legendary Czech princess, Libuše. Nevertheless, both architects also designed large apartment buildings in the area of the former Jewish ghetto, whose modest decoration and simple elegance were a manifesto against the often overdecorated bourgeois palaces which flanked nearby Pařížská Avenue.

Another interesting personality of this generation was Emil Králíček, who studied in Darmstad under Wagner's student, Joseph M. Olbrich. In Prague, Králíček cooperated closely with leading construction firms and, above all, with Matěj Blecha, something that has resulted in his authorship often remaining hidden in anonymous company project documentation. Yet his expression remains so distinctive that he can be considered the author of many important architectural achievements carried out in the pre-war years in the New Town around Wenceslas Square (such as the Adam Pharmacy on Wenceslas Square, 1911–1912).

Individual yet very typical buildings of this period were studio houses designed by the artists themselves. The most important is František Bílek's studio, from 1910. Its motivation is ideological and symbolist, yet at the same time it is executed in a contemporary form, contributed to by the flat roof, one of the first in Prague. A similar studio was built by Ladislav Šaloun in Prague-Vinohrady.

In 1910, the new school of architecture, part the Academy of Fine Arts, was established and Jan Kotěra became a professor there. His position at the School of Decorative Arts was given to Jože Plečnik, one of Wagner's most outstanding students of the first modern generation. Plečnik left his mark on Prague after World War I, when the Czechoslovak president Tomáš Garrigue Masaryk invited him to be the main architect for modifications to Prague Castle.

At that time, Jan Kotěra's architectural expression further developed and matured. He built the Mozarteum, a house with its own concert hall, for the publisher Mojmír Urbánek on Jungmannova Street in 1911–1913. The building's brick elevation, inserted in the gradated concrete frame and topped with a classical triangular gable, bears witness to the fact that the new purism made frequent use of decorative effects stemming from the application of basic building materials. Kotěra's buildings were a hallmark of the maturing taste of Czech national society, which no longer demanded a national ethnic distinctiveness, but which decided to compete in the field of universal modern expression. Kotěra was then commissioned to build large and iconic buildings, such as the General Pension Institute in the New Town (1912–1914) and the new university building near Svatopluk Čech Bridge, which was only completed after the architect's early death in the 1920s.

The development of modern architecture in Prague in the pre-war years concluded with a remarkable period of cubism. This most avant-garde movement was promoted in Prague by the Group of Visual Artists, which seceded from the

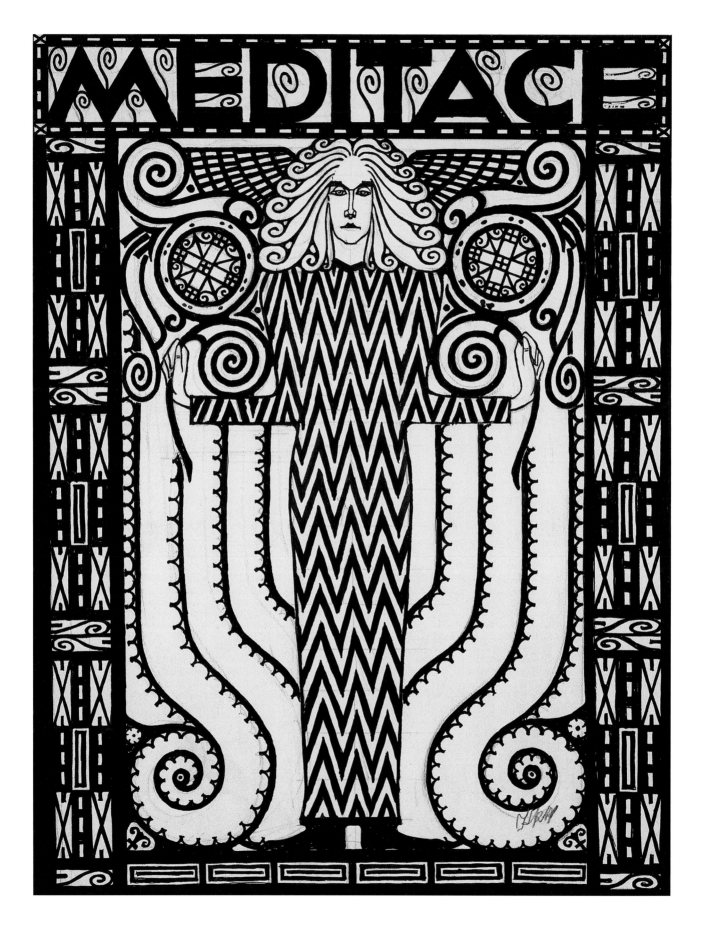

Art Nouveau Mánes Association in 1911 and was principally led by painter Emil Filla and sculptor Otto Gutfreund. In Prague, cubism was not only applied to fine arts, but also attracted many architects and designers. In reality, Czech cubism was the distinctive culmination of the idea of uniting art and life, which acted for the Czech modernist movement as the foundation for the search for a new style at the turn of the century. The hub for the new expression of this idea was the cooperative society Artěl, founded in 1908, which offered artisanal products, of which ceramics in particular became models for the new style, just as in 1900. It was only after this that Josef Gočár and Josef Chochol applied cubism to the architecture of apartment buildings and villas, with its attendant impact on the city's exterior.

Prague, which was largely spared destruction during both world wars, has at its centre a remarkable open-air museum of both ancient and modern architecture. A stroll along the city's streets, embankments, and squares offers an incomparable opportunity to see a testimony to various historical periods and architectural personalities standing side by side. Only through closer identification of the origins and artistic character of the individual buildings and their complexes can we understand the unique character of Prague, whose genius loci conveys a remarkable unity in its variety. The multifaceted expression of Prague's architecture suggests that its creators, along with its commissioners and users, could impart the strong emotional ties that bound them to their homes. A better knowledge of this history also guarantees that it will persist.

JAN KONŮPEK: **Design of a cover for** *Meditation* **magazine**, 1909, India ink on paper, 49.4 × 37.4 cm, National Gallery Prague

Konůpek's design captures the closing stage of the Art Nouveau style, when the original naturalism entirely gave way to a symbolic theme expressed in geometric, ornamental patterns. The popular motif of the spiral, replacing the earlier arabesque, rapidly took over decorative ornamentation in architecture.

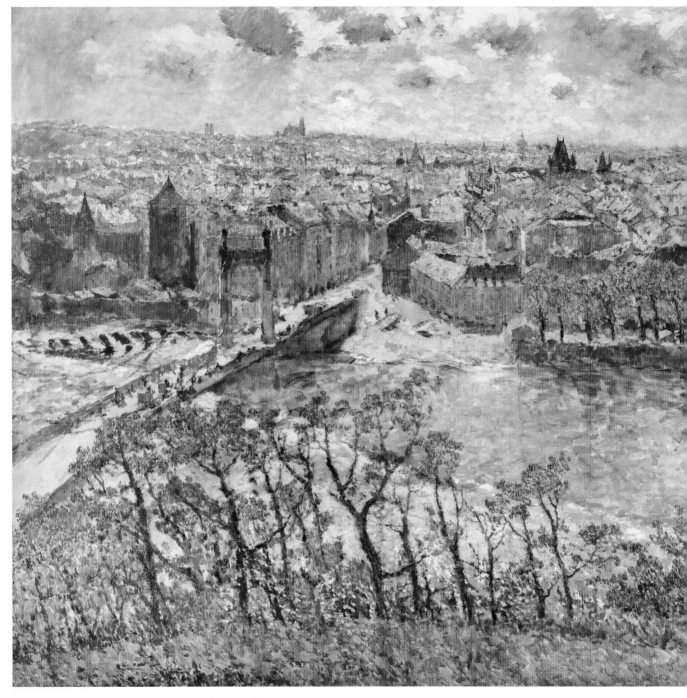

ANTONÍN SLAVÍČEK: **Prague from Letná Park**, 1908, tempera on canvas, 185.5 × 390 cm, National Gallery Prague

In May 1908, Slavíček spent two weeks painting a four-metre panorama of Prague, which he sent to the Exhibition of the Chamber of Commerce and Trade in Prague as his masterly response to the paintings of the time. He wrote about it in a letter to art patron August Švagrovský: "I saw in front of me a city full of hustle and bustle – a modern city, but with ancient gothic spires, genuine vestiges of the bygone Middle Ages. I filled the city with sunlight and when I saw it, I was very happy…"

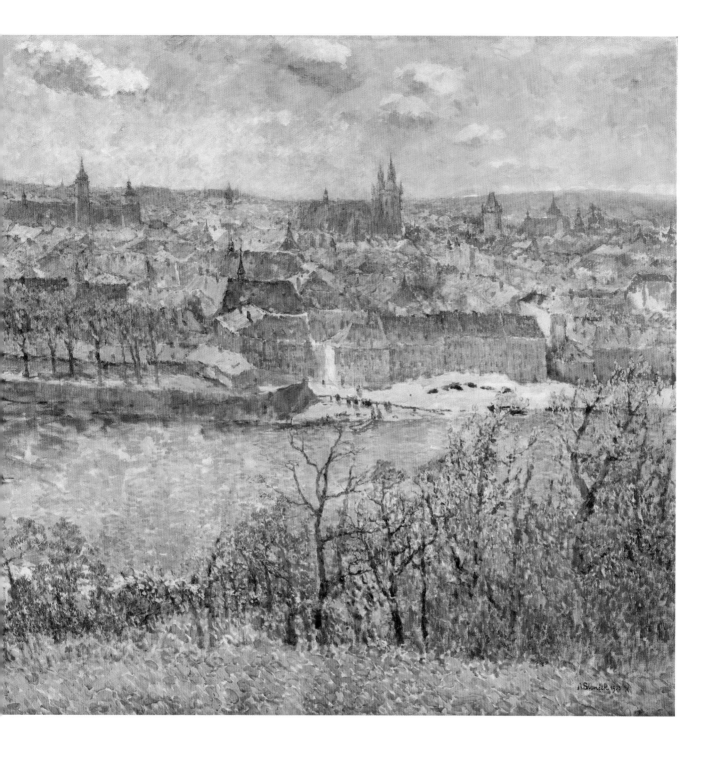

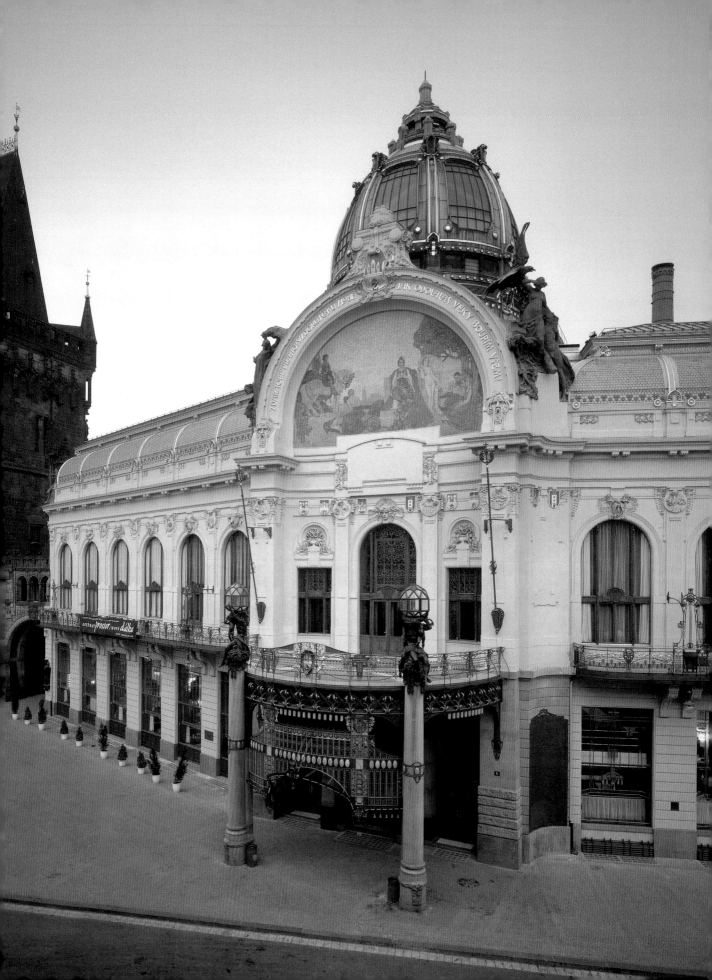

ART NOUVEAU PRAGUE –
AN ILLUSTRATED GUIDE TO THE CITY

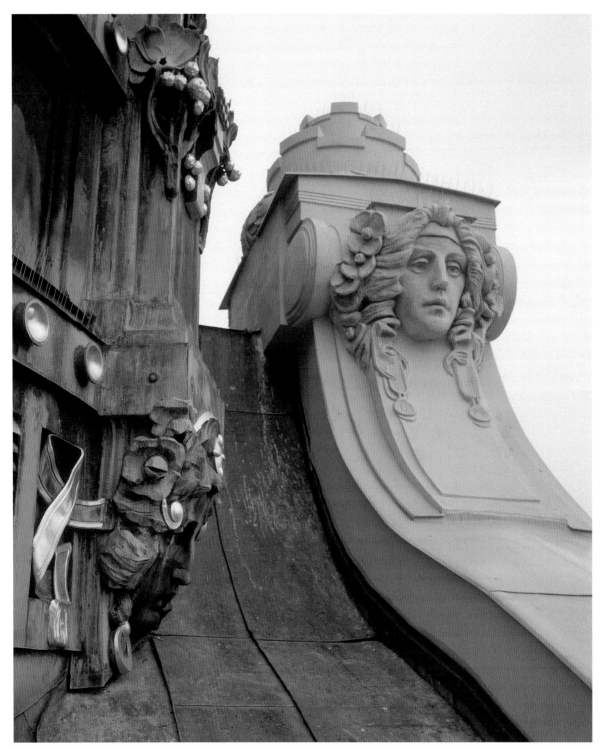

A detail from the Municipal House dome

The ceremonial building of the Prague municipality, the
Municipal House, is a prominent and typical example
of the Prague Art Nouveau style. It is situated at an
important intersection outside the entrance to the Old
Town, marked by the medieval Powder Tower. Since it was
impossible to identify a winner of the 1903 competition,
Antonín Balšánek and Osvald Polívka were commissioned
to prepare its design. Construction commenced in 1905
and, after incurring immense costs of 6,430,000 crowns,
it ceremoniously opened to the public in January 1912.
The intriguing façade with its broken front epitomises the
archetypal Prague blend of Art Nouveau and traditional
neo-baroque elements. The entrance is marked by a richly
decorated awning with Karel Novák's *Torchbearers*, which is
surmounted by a semicircular gable with a mosaic by Karel
Špillar on the theme of the *Apotheosis of Prague*, flanked
by Ladislav Šaloun's dramatic sculptures. The building is
dominated by a slender dome, which allows for natural
lighting of the interior.

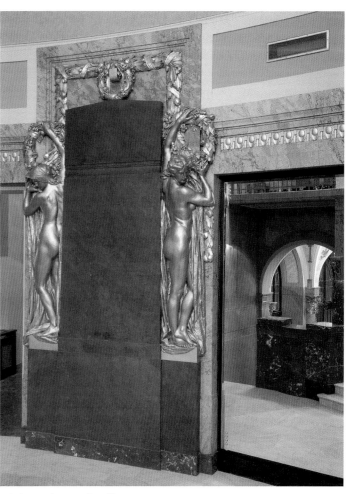

Main staircase landing

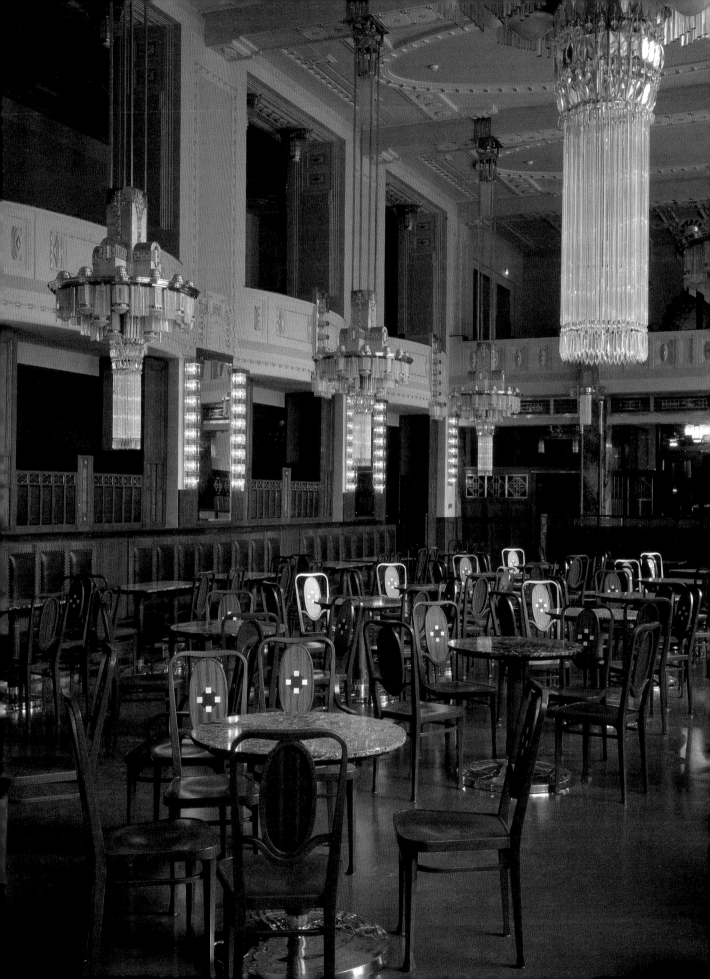

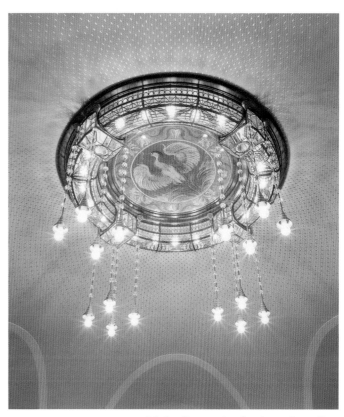

Light fixture in the American Bar

Large halls and parlours on the main floor of the Municipal House were primarily used for ceremonial purposes. The centrally located octagon of the Mayor's Hall was designed and solemnly decorated by Alphonse Mucha in 1910–1911, including the poignant paintings, *Sacrifice*, *With Our Own Strength*, and *Masculinity*, which aimed to reinforce the triumphalist significance of the Czech national idea. The ceiling features an ornamental circle of figures that imply Slavic concord. Other halls are dedicated to the memory of prominent Czech figures and decorated by leading artists. Palacký Hall features Jan Preisler's paintings representing the golden age of mankind, while leading Czech writers, musicians, and artists are represented in two murals entitled *Czech Spring*, created by Max Švabinský for the Rieger Hall. Grégr Hall is decorated by František Ženíšek's neo-romantic triptych, *Love Song*, *War Song*, and *Funeral Song*. The centre of the building's plan is occupied by Smetana Hall, enhanced by Karel Špillar's allegorical murals featuring the ideal themes of *Music*, *Dance*, *Poetry*, and *Drama*. The sides of the proscenium are enhanced by two large allegorical stucco sculptures by Ladislav Šaloun, called *Slavonic Dances* and *Vyšehrad*. Smetana Hall is to this day still the largest concert hall in Prague, hosting many international festivals, including the Prague Spring Festival.

The large building of the Municipal House contains many other communal areas. The Exhibition Halls continue to host first-class art exhibitions. The restaurants display stylistic variability – from the rustic Folk Restaurant decorated by Jakub Obrovský's paintings and the American Bar in the basement, to the refined Art Nouveau French Restaurant with mural paintings by Josef Weinig, on the ground floor. The whole is completed by a spacious café, featuring a fountain, and many smaller parlours for club activities, as well as the Gaming Rooms, Oriental Parlour, and several parlours designed for ladies, such as the Confectionery, with its intimate furnishing. This versatile nature made the Municipal House a lively centre of the Czech community and cultural life.

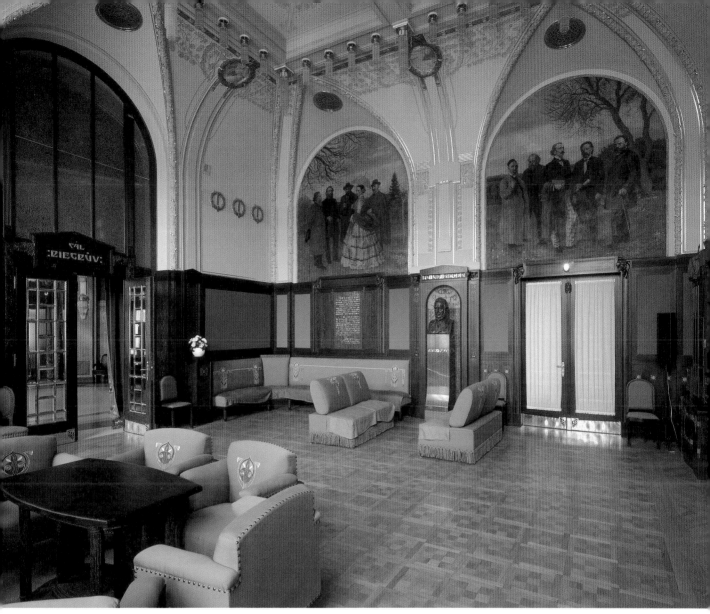

Rieger Hall

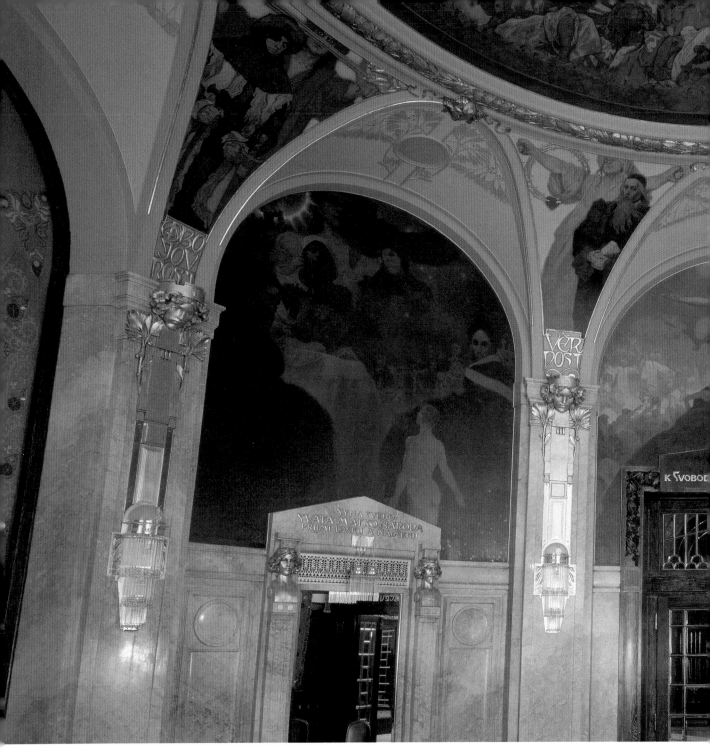

Mayor's Hall

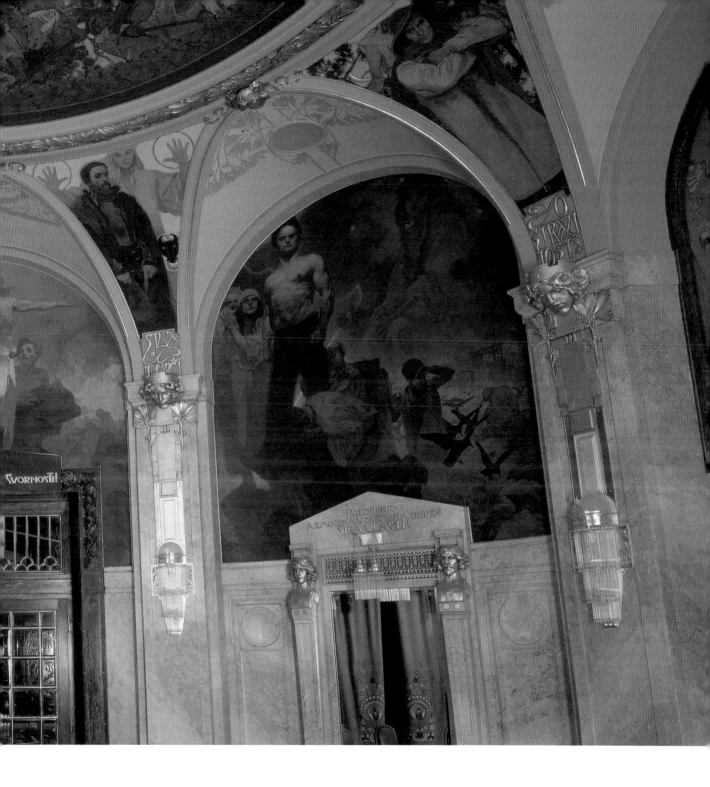

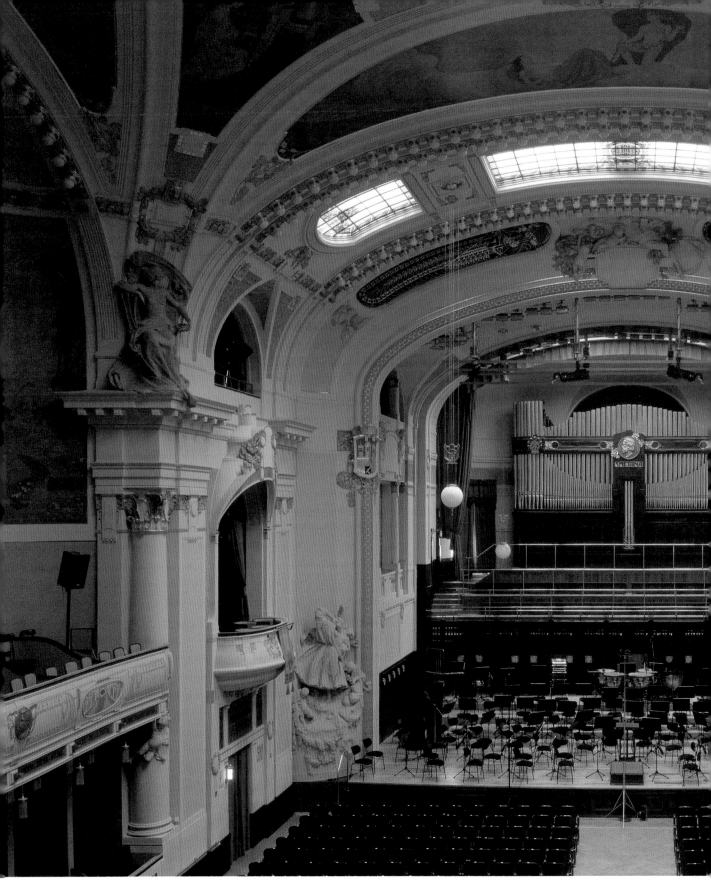

Smetana Hall

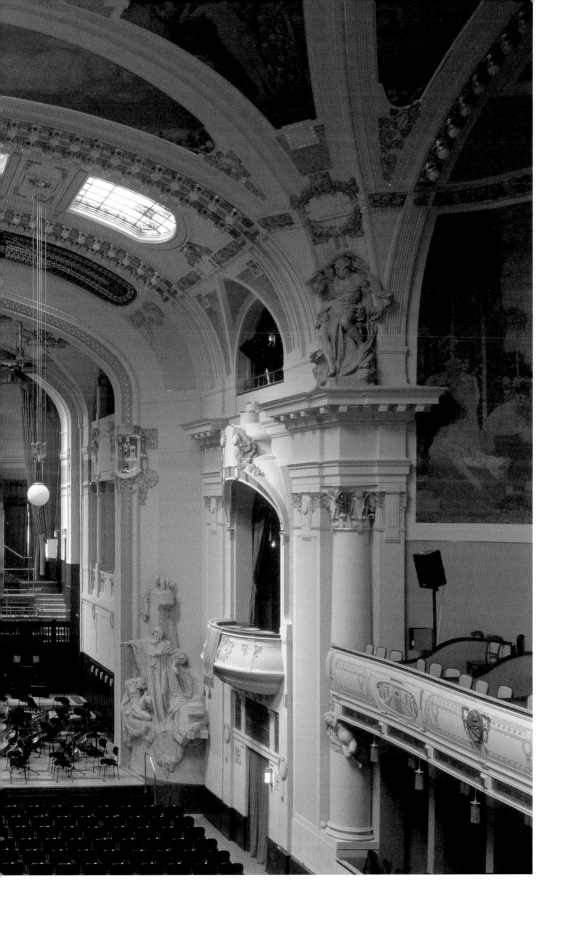

(53)

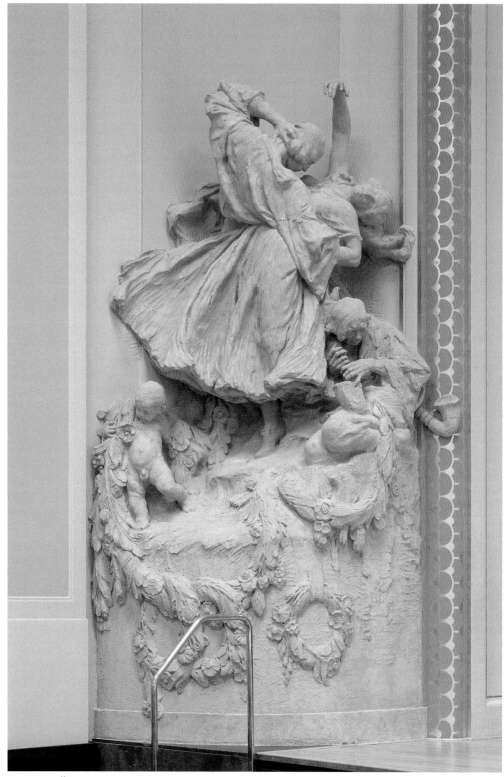

Ladislav Šaloun: *Slavonic Dances*

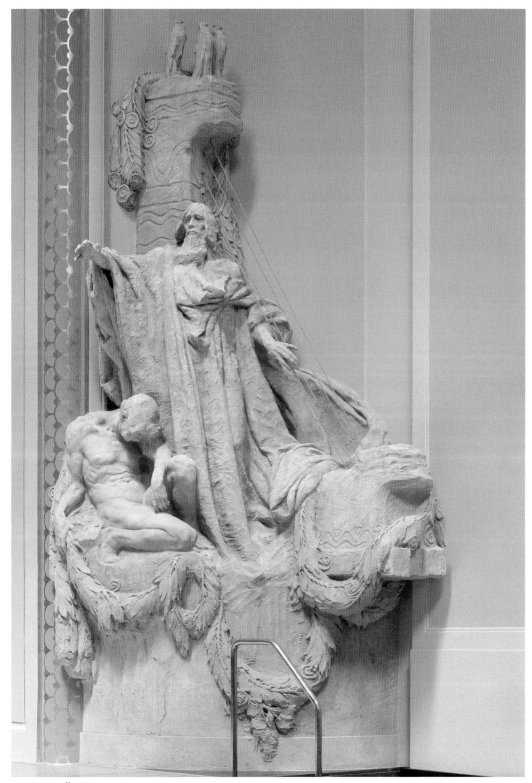

Ladislav Šaloun: *Vyšehrad*

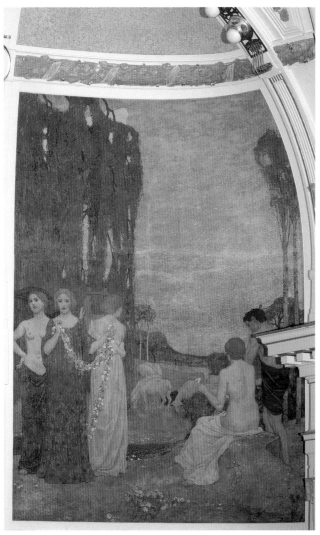

Karel Špillar: *Dance*

Karel Špillar: *Music*

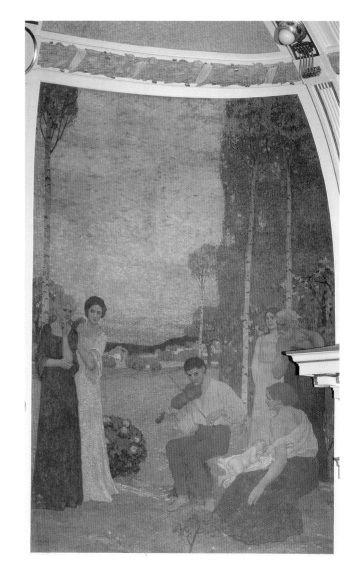

(57)

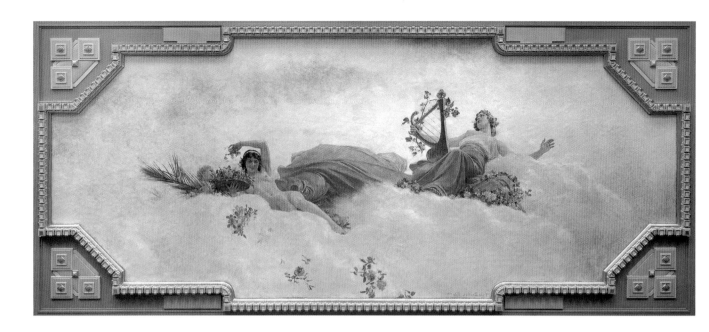

Grégr Hall

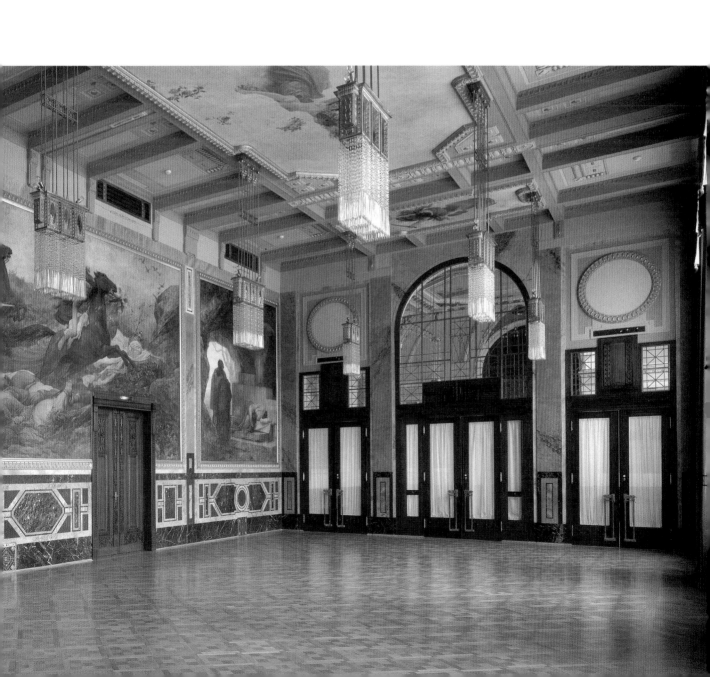

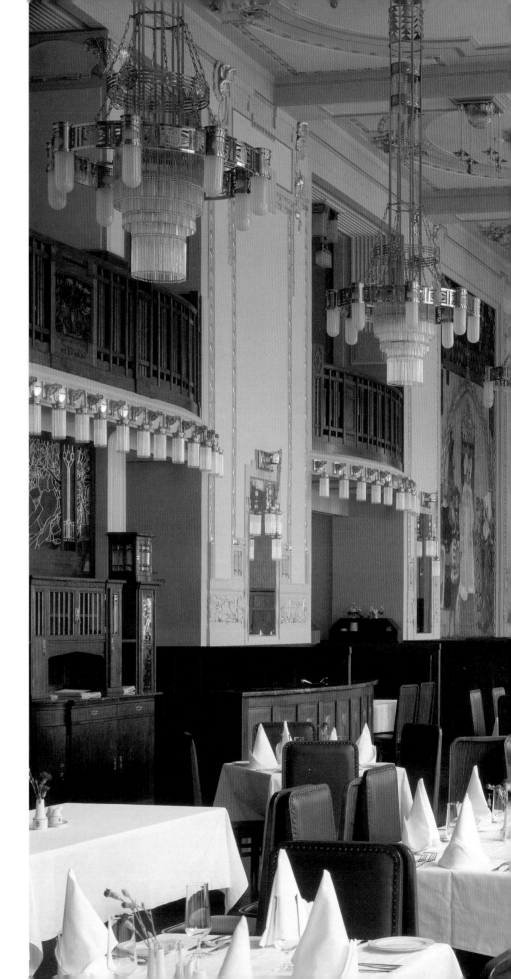

Grand Restaurant /
French Restaurant

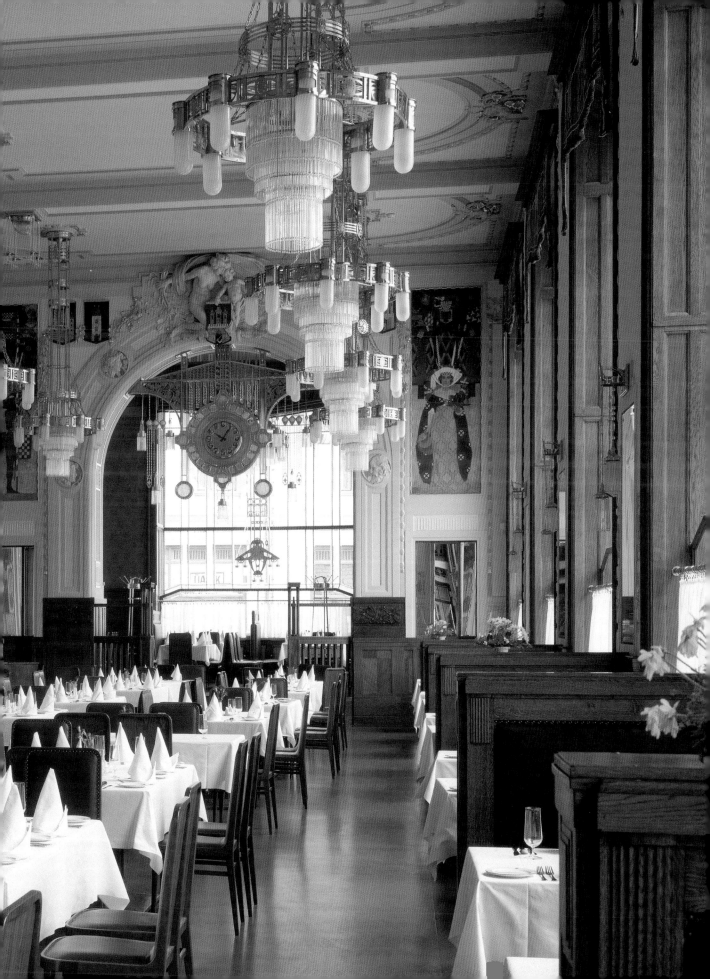

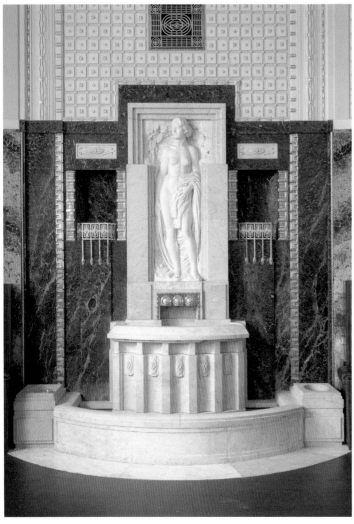

Fountain next to the Café

Fountain in Božena Němcová Parlour

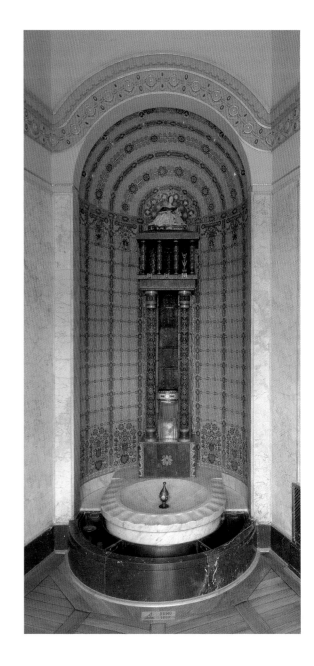

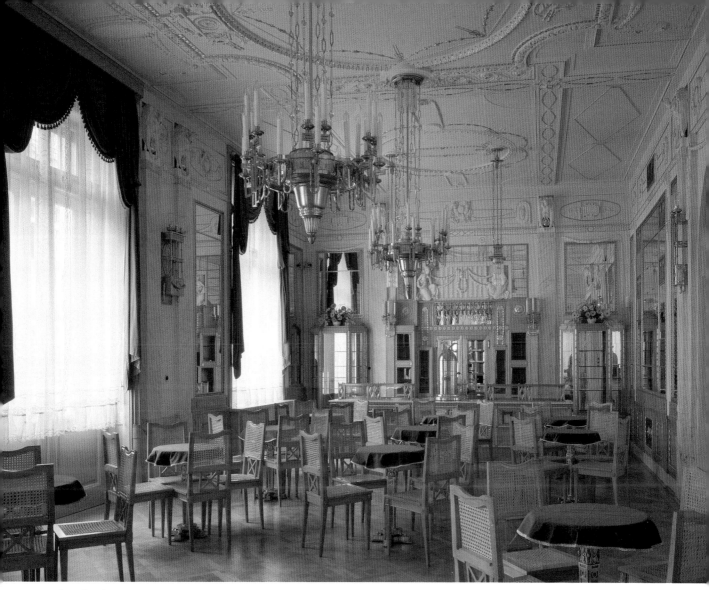

Confectionery

The rear of the Municipal House

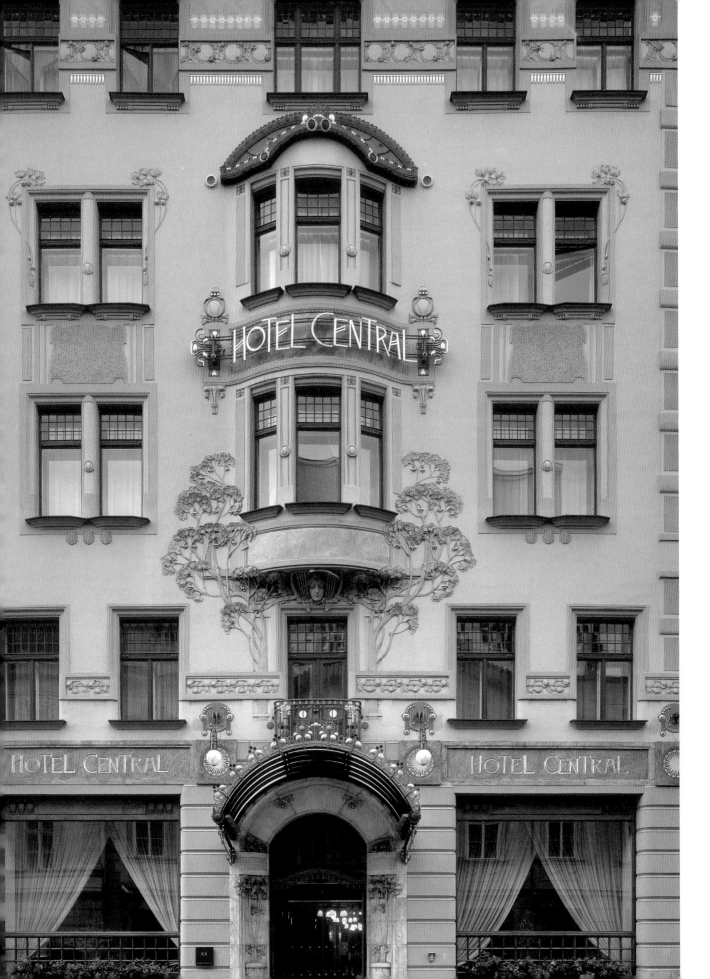

At the end of the 1890s, Art Nouveau entered the Prague architectural scene as the most modern of styles. Among its first achievements was the former Hotel Central on Hybernská Street, designed in 1898 by Friedrich Ohmann, a professor at the School of Decorative Arts in Prague. The construction of the hotel, which was an important community centre, was completed two years later by Ohmann's students, Bedřich Bendelmayer and Alois Dryák.

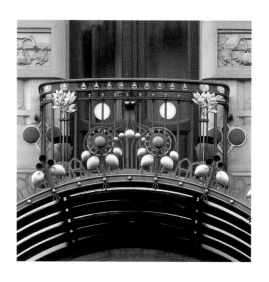

The building, while altered by numerous reconstructions, has preserved its remarkable front façade, recently restored. The colour scheme, combining green and reddish hues highlighted with gold, reveals Ohmann's Viennese inspiration. Typically Art Nouveau are the sculpted elements of decoration, namely the motif of vegetation stretching around the central shallow oriel, motifs on the gable and on the stone portal, as well as the mascaron under the oriel, which all allude to the influence of symbolist poetry on architectural style. August Rodin was one of the hotel's first guests, staying here during his visit to Prague in 1902 when his exhibition opened. After World War I, the hall with a stage hosted the Red Seven Cabaret and cinema. In the 1930s, the fantastic shapes of the hotel lift were admired by surrealists from Paris, including André Breton.

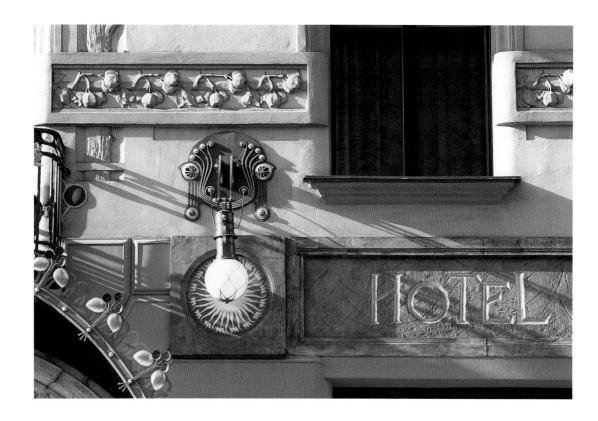

3/ TWIN APARTMENT BUILDINGS ON U PRAŠNÉ BRÁNY STREET

Bedřich Bendelmayer's twin apartment buildings on U Prašné brány Street, from 1903–1904, are among the most interesting achievements of the Prague Art Nouveau style. During their construction, they were sharply criticised by conservatives for their alleged disrespect for tradition. This was mainly because of the dominant feature of the "glass" studios and the bands of iron railing stretching along the entire length of both buildings. Their ornamentation was unusual for its stylisation, surpassing the naturalistic taste of the previous years. In the 1910s, the studio was rented by painter Max Švabinský.

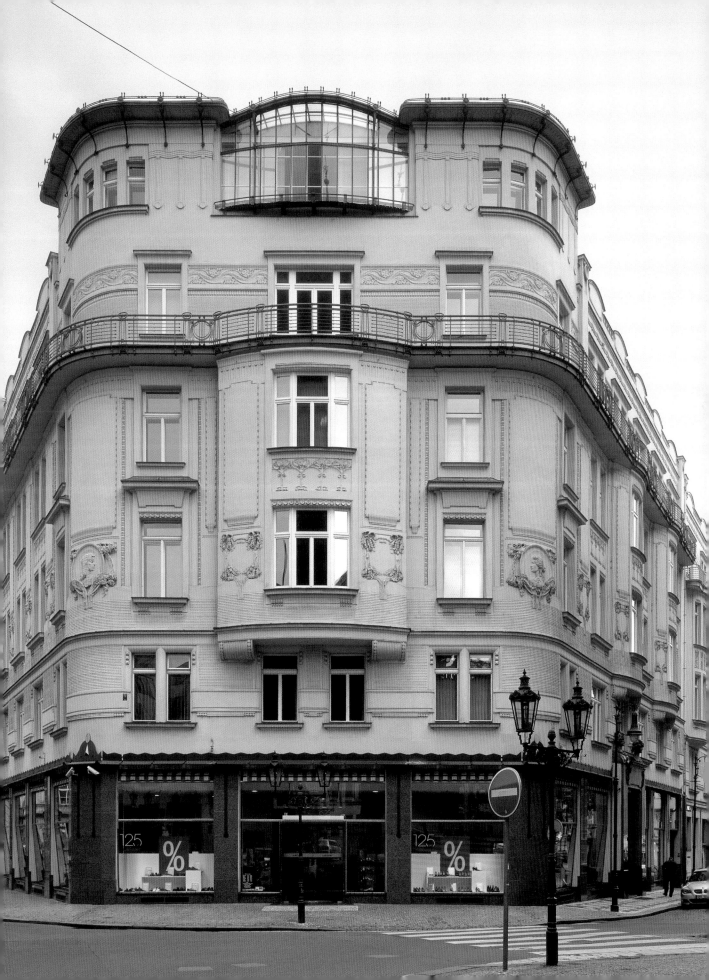

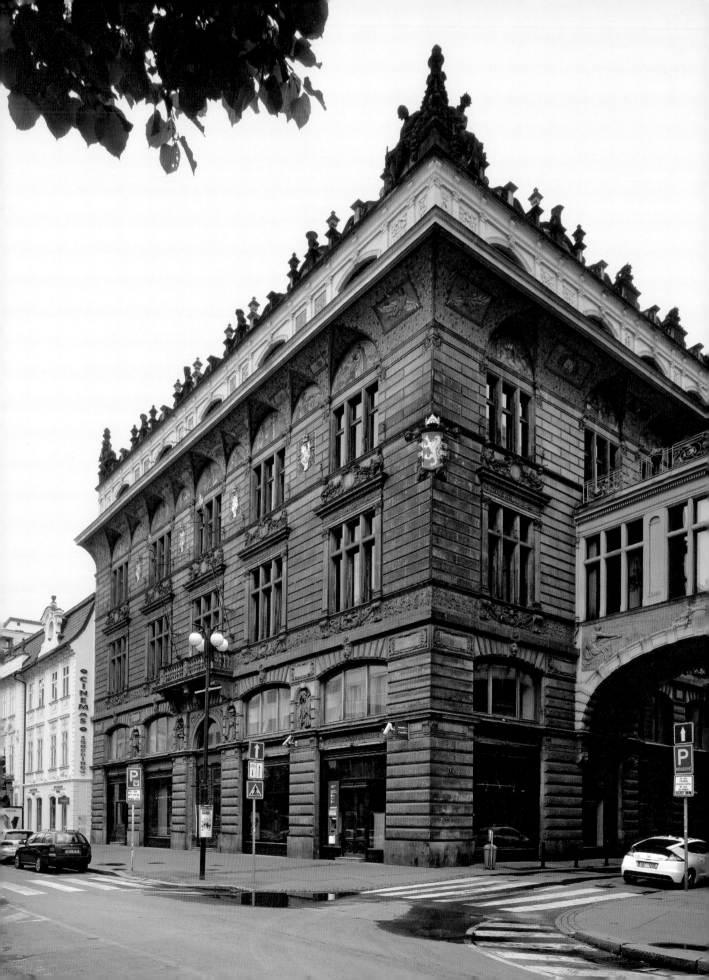

4A–D/ LAND BANK

The Land Bank, designed by architect Osvald Polívka, was built in 1894–1896 on the prestigious Na Příkopě Street. Its style is based on the neo-Renaissance, although the façade, remarkable for its fluidity and richness, evokes the Nordic and mannerist canon. The sculpted decoration by Celda Klouček and Stanislav Sucharda works in harmony with the colourful lunette mosaics designed by Mikoláš Aleš and flower decoration by Anna Boudová. In attractiveness, the interior matches the exterior, a joint work of a large group of painters, sculptors, and decorators. The entrance hall, enhanced by two large murals by Max Švabinský, is connected to a stair hall with lunettes by Karel Vítězslav Mašek and a romantic staircase guarded by torchbearers by Bohuslav Schnirch. Its top floor contains a spacious hall with a painted glass ceiling and decorated with fanciful, naturalist personifications of Czech regions, which were created by sculptors Stanislav Sucharda, Antonín Procházka, František Hergesel, and Bohuslav Schnirch. Stylistically, the Land Bank is a typical example of the loosening of historicism in favour of visual richness. In 1911–1912, Polívka constructed another building for this bank, on the opposite corner of the street, whose façade is decorated with Jan Preisler's Art Nouveau mosaics.

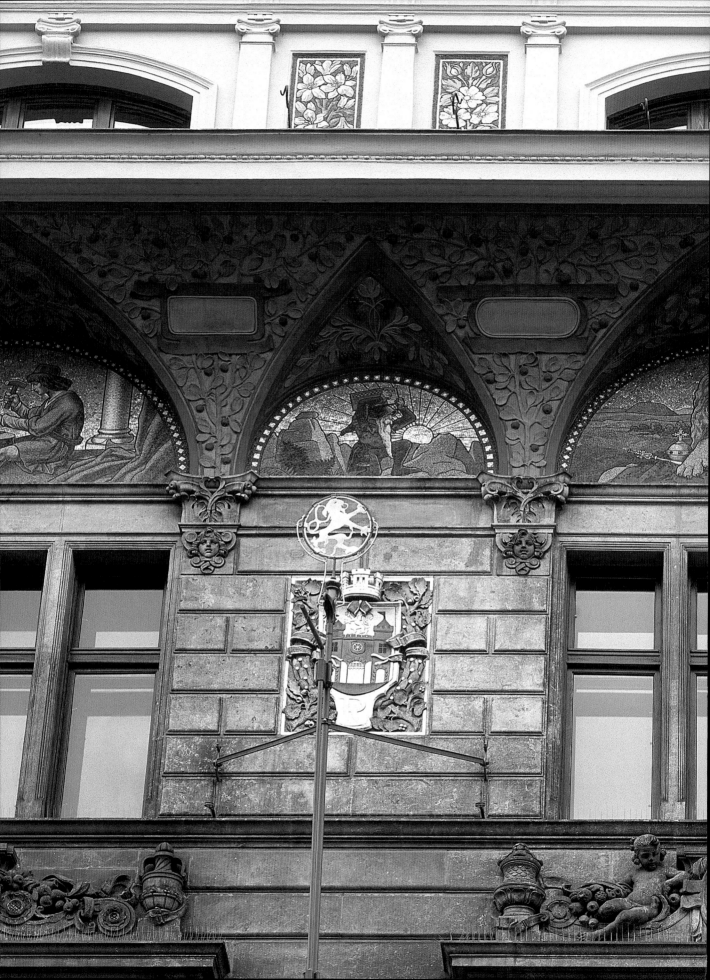

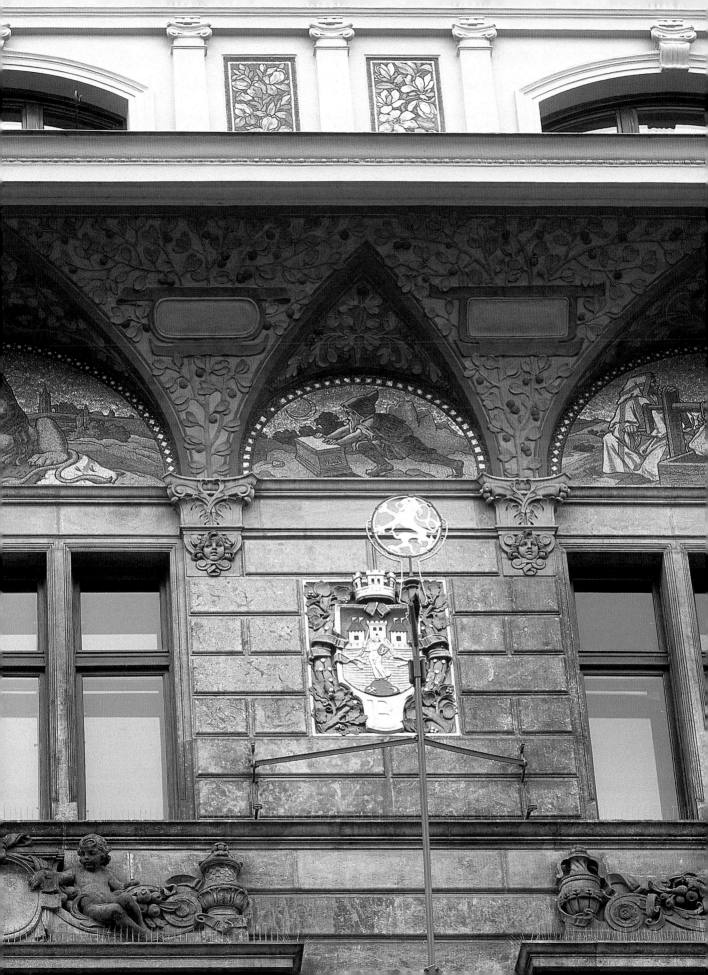

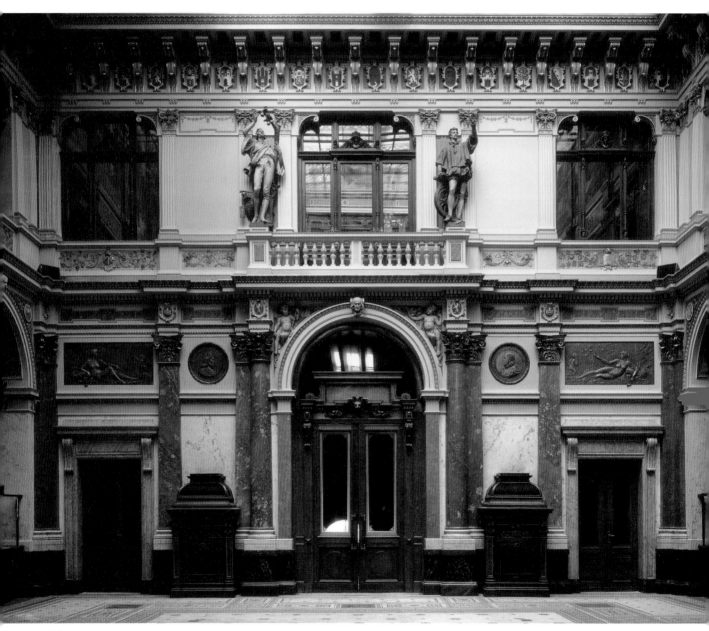

Lobby

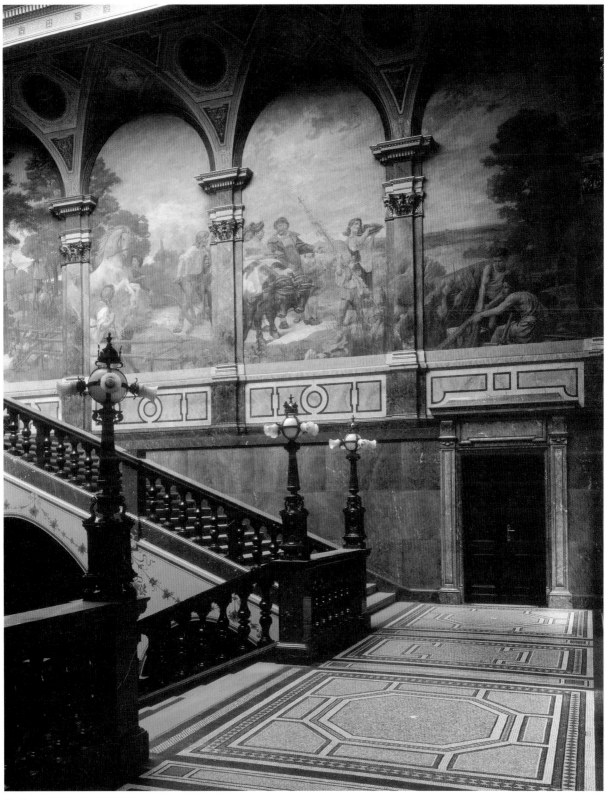

Staircase

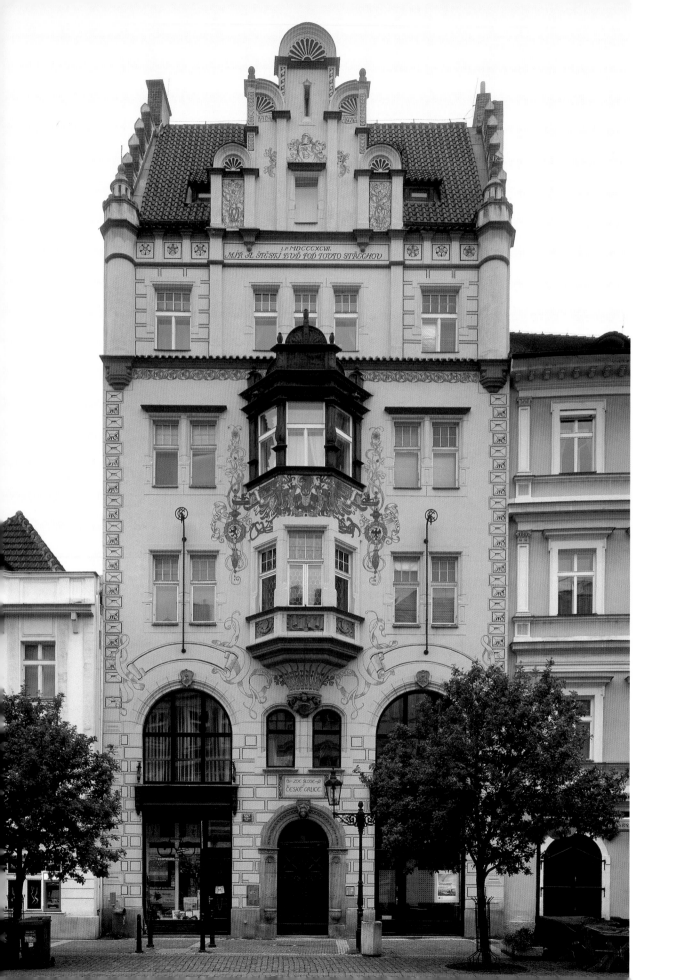

5A–B/ BOHEMIAN EAGLE HOUSE

The Bohemian Eagle House (U České orlice) was designed in 1897 for the Czech doctor Čeněk Klika by Friedrich Ohmann, a professor at the School of Decorative Arts. The historic elements, such as an oriel and gables, are used quite freely, in the fading spirit of attempts to create a Czech national style. However, the halls of the half-storey shopping area are modern. In addition, the painted decoration of the façade, designed by Mikoláš Aleš, enhances, rather than suppresses, the wall surface, heralding Art Nouveau ornamentation. The house, built on a deep medieval plot of land, has another, more modest, façade facing Celetná Street.

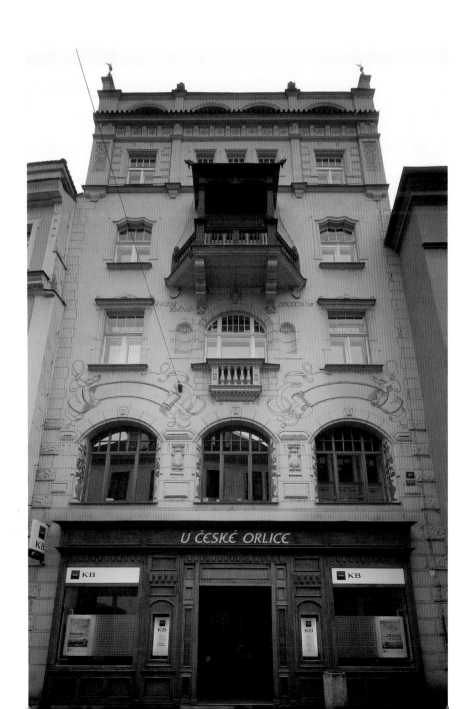

6A–C/ BLACK MADONNA HOUSE

Kotěra's student Josef Gočár presented a truly original solution to the problems of monument preservation resulting from Prague's redevelopment, by erecting the Black Madonna House (U Černé Matky Boží) on Celetná Street in 1911–1912. He did not succumb to traditionalism, but instead brought back to life the concept of geometric modernism by incorporating the most recent Cubist elements, visible particularly in the concept of the portal. This marriage of styles surprisingly met the demands for incorporating the building into the historical environment, while at the same time showcasing the basic dynamics of the Art Nouveau style.

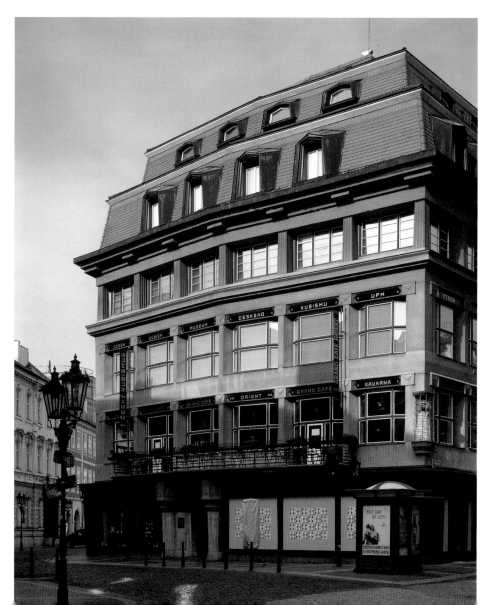

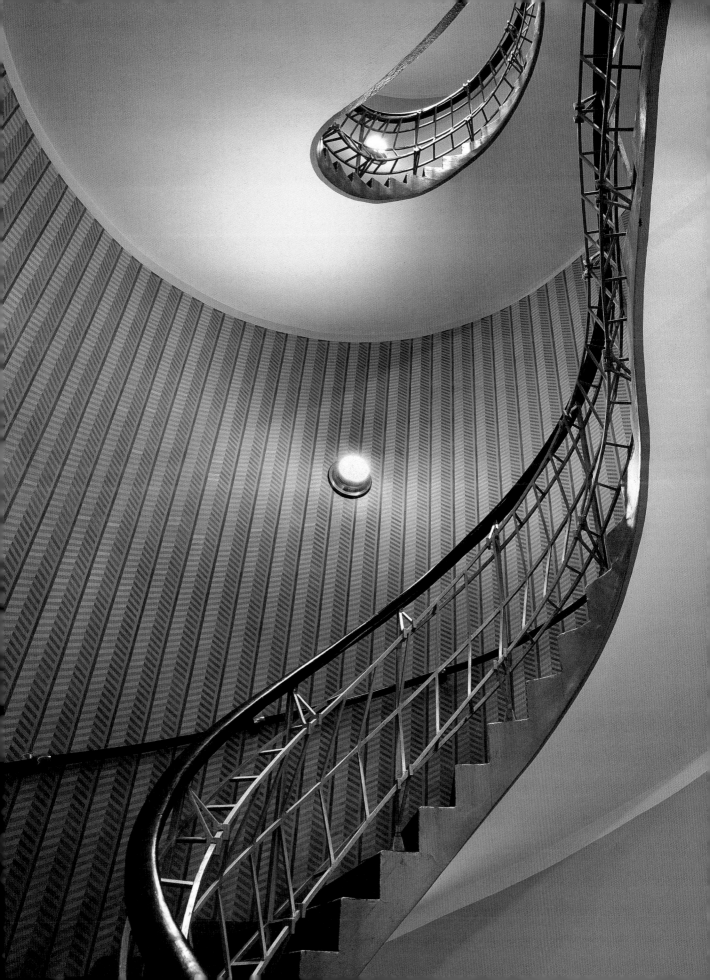

7A–B/ JAN HUS MONUMENT

The decision about the location of the monument to the national martyr, Master Jan Hus, was preceded by long discussions at the City Council. In the end, the most prominent site in Prague, the Old Town Square, was selected over another alternative, Betlémské Square, despite the strong argument that the Old Town Square already had a prominent feature: the baroque Marian column. The second competition in 1900 was won by sculptor Ladislav Šaloun, but the contract was not signed until 1905. In 1907, the Club for Old Prague protested against its site on aesthetic grounds, when a slate model of the monument's silhouette was installed as a trial. The construction of the architectonic base began in 1913 and during the following year metal parts were installed. It was not until 1915, during World War I, that the monument was quietly unveiled. In addition to the upright figure of Hus, the composition emphasises a group of Hussite warriors. This band of exiles is positioned to face the spot where the degrading execution of members of the Bohemian Estates resistance against the Habsburgs took place. The front of the monument bears Hus's message to the nations: "Love one another and grant the truth to everyone." The emotional content of the monument is underlined by its mighty expression of forms.

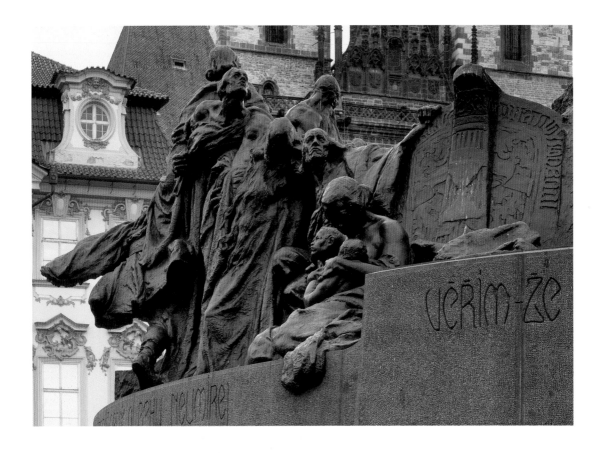

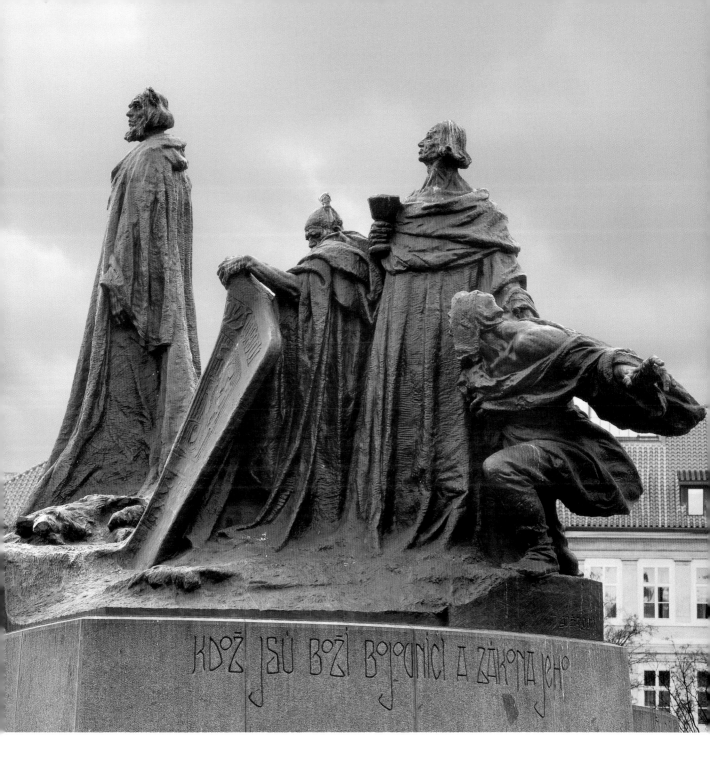

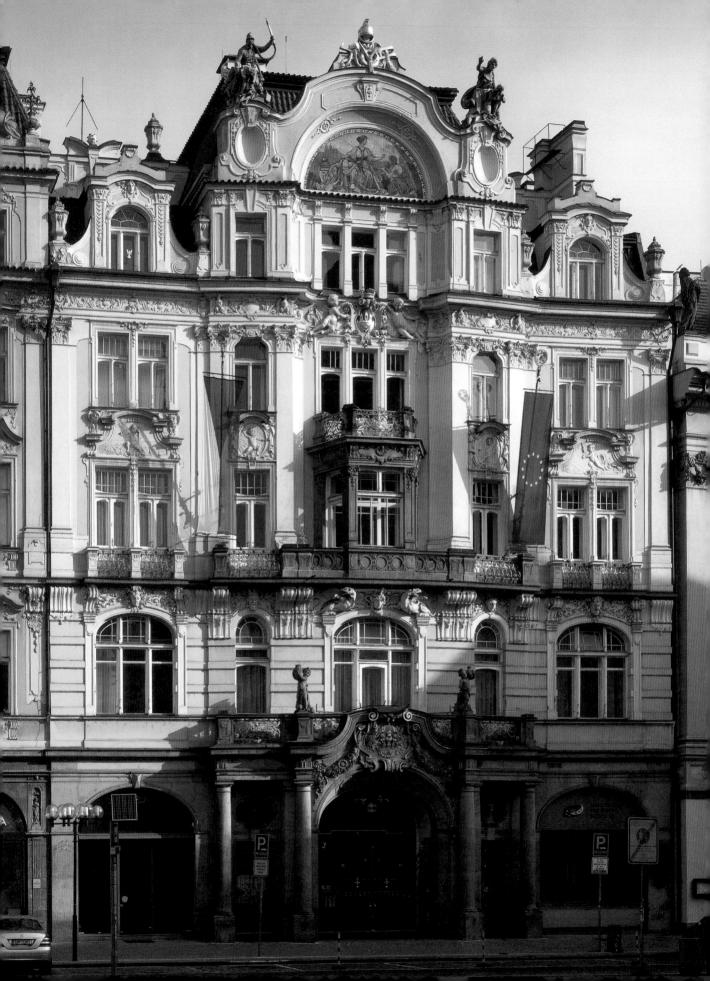

8A–D/ PRAGUE CITY INSURANCE COMPANY

Prague City Insurance Company, built in 1899–1900,
replaced three baroque houses on the northern side
of the Old Town Square, the starting point of the famous
Old Town slum clearance. This far-reaching urbanist act,
which at first ruthlessly destroyed valuable old monuments,
brought about a storm of intellectual protest. Architect
Osvald Polívka's design was quite a successful attempt
to calm this upheaval, as the building was adapted to
the traditional atmosphere both by its segmentation and
its decoration. Polívka and his collaborators, including
sculptors Bedřich Schnirch and Ladislav Šaloun, therefore
selected the neo-baroque style but enhanced it with the
artistry which was so highly prized at the time. The rear
of the building, facing Salvátorská Street, bears strong
Art Nouveau features.

The rear of the building →

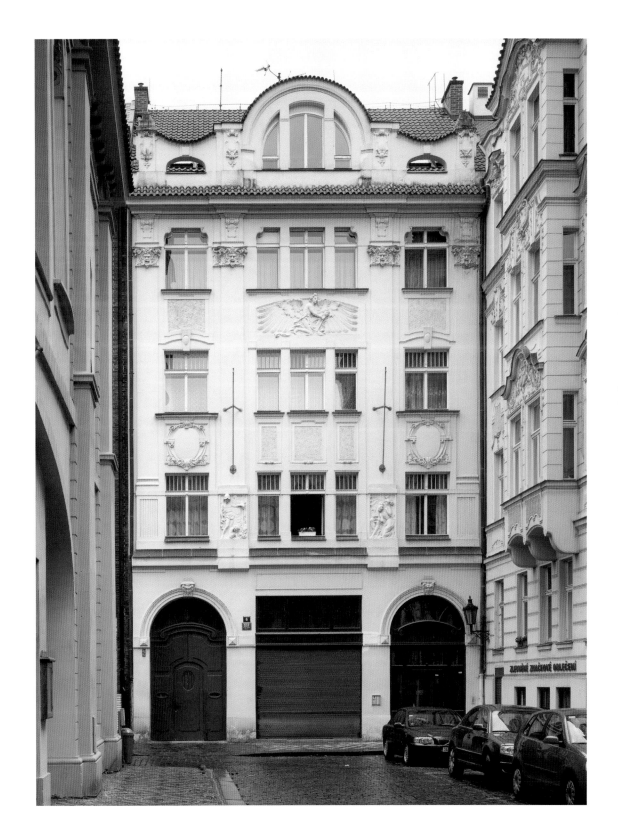

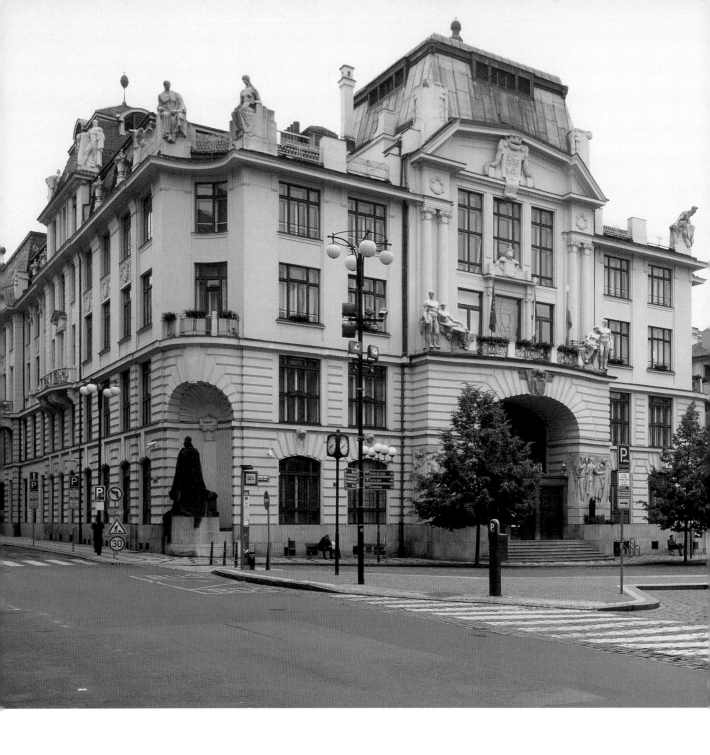

9A–C/ NEW CITY HALL

The extraordinary contribution of sculpture to the character of Art Nouveau in Prague is exemplified by the front façade of the New City Hall, designed by Osvald Polívka. It was built in 1908–1911 in Mariánské Square, which had been cleared of houses during the city redevelopment. The works of participating sculptors – Stanislav Sucharda (statues around the entrance portal), Josef Mařatka (the athletic groups *Strength* and *Perseverance* on the balcony over the main entrance), and Ladislav Šaloun (*Rabbi Loew* and *Stone Knight* in the side niches) – demonstrate the development of artistic taste, as it evolved towards a new classicism. Polívka's architecture also emphasises the classical elements in its details, yet it does not renounce the basic dynamics of forms, which are still grounded in the Prague Art Nouveau style.

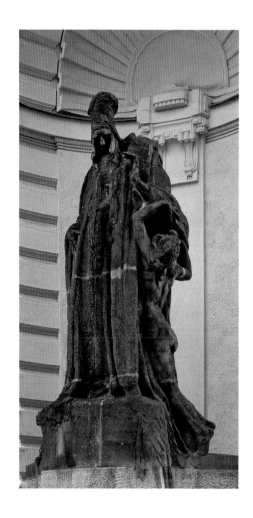

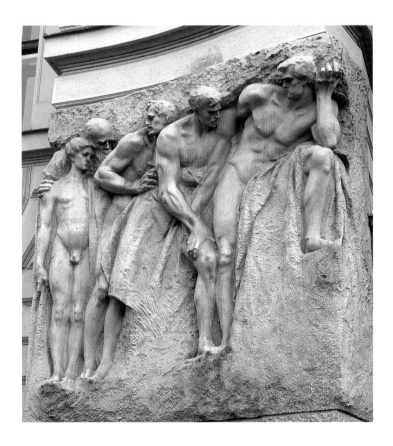

Ladislav Šaloun: *Rabbi Loew*

Stanislav Sucharda: Sculpted decoration by the entrance

The Museum of Decorative Arts was built in Prague
in 1896–1901. Architect Josef Schulz, who also designed
the National Museum building, chose a more intimate
neo-Renaissance form, which better suited the purpose of
this building: collecting the treasures of the historical and,
before long, also the modern, arts and crafts. The Museum
of Decorative Arts, founded by the Chamber of Commerce
in Prague, simultaneously promoted contemporary applied
arts and strove to bridge the gap between the present and
the past. The library, well stocked and furnished, became
its lively centre, and serves the same purpose to this day.
The museum collections contain outstanding examples
of Czech and European artistic crafts.

The Museum of Decorative Arts owns a large collection
of Czech Art Nouveau craft objects. A special collection
focuses on world-famous colour glass produced by
glassworks such as Johann Lötz vdova, Klášterský
mlýn (E) and Elisabeth, Pallme – König & Habel, Košťany
u Teplic (F), often iridescent and hand blown in original
shapes. Another collection features works by professors
and graduates from the School of Decorative Arts in
Prague, excelling in ceramics (B, C), work with metal
and precious materials (G, H, I), and woodworking (J).
Another interesting collection focuses on designs by
architects from the period of geometric modernism (D, I).

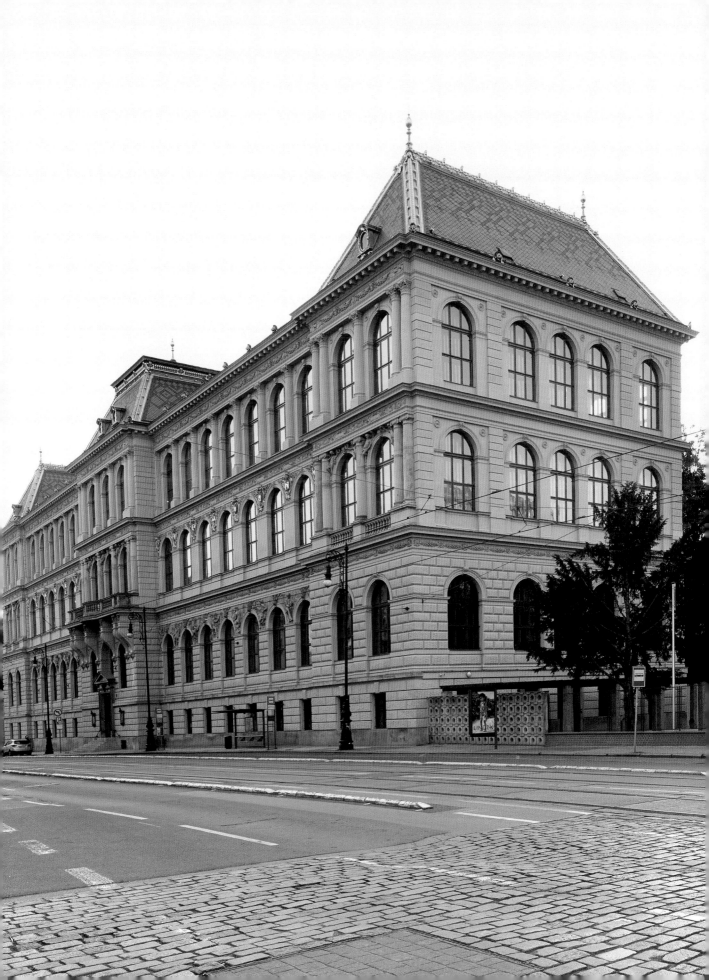

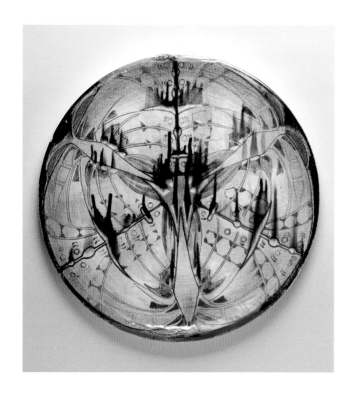

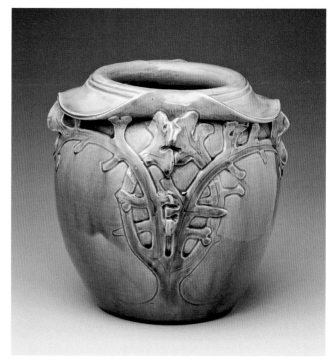

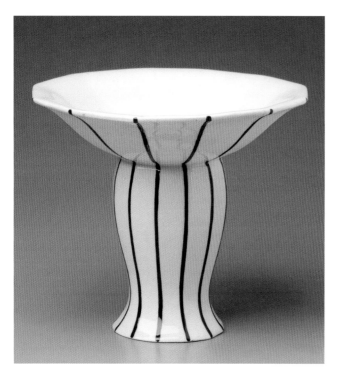

10B/ A bowl decorated by stylised butterflies, Anna Boudová-Suchardová, ca. 1900, fired clay, engobe, colour underglaze, lead glaze, diam. 34 cm

10C/ Vase, František Soukup, 1904, earthenware, blue glaze, 17.5 cm

10D/ Small chalice vase, Pavel Janák, 1911, soft earthenware, white glaze, black lines

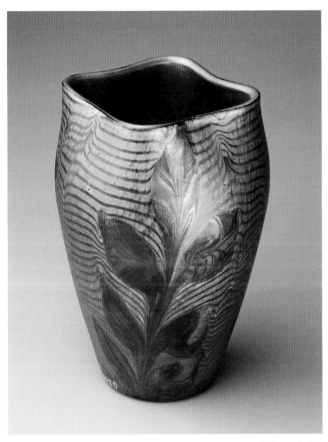

10E/ Vase, Johann Lötz vdova glassworks, Klášterský mlýn, ca. 1902, clear glass with brownish opaline overlays on both sides, hand blown, iridescent, 14.5 cm

10F/ Vase, Elisabeth, Pallme – König & Habel, Košťany u Teplic, ca. 1902, green glass, hand blown, 9.5 cm

10G/ Box of chocolates, Karel Ebner, 1909, silver, partly gilded, mother-of-pearl, coral, moonstone, turquoise, w. 6.5 cm

10H/ Brooch, Josef Ladislav Němec, after 1900, gilded silver, mother-of-pearl, carnelian, 5.5 cm

101/ Candlestick, Emanuel Novák Studio, 1908, poured brass, 20 cm

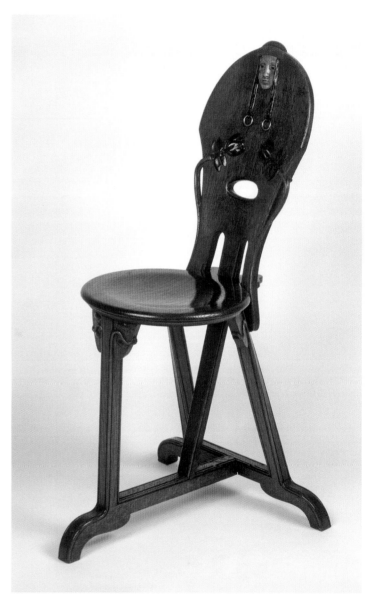

10J/ Chair from the interior of the School of Decorative Arts in Prague at the Paris World's Fair in 1900, Jan Kastner, 1899, oak and walnut wood, cut, polychromed, 92 cm

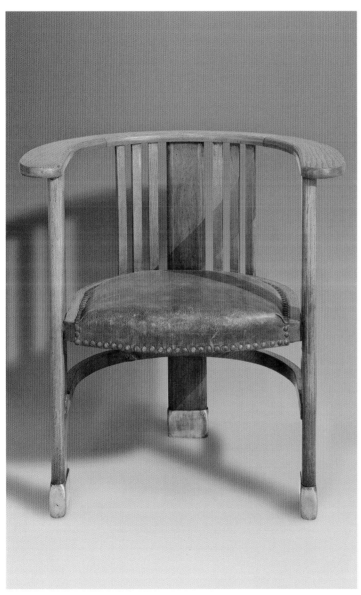

10K/ Armchair from Jan Laichter's dining room, Jan Kotěra, 1907–1908, oak, leather, copper, 77.5 cm

11A–C/ ENGEL'S VILLA AND APARTMENT BUILDING FOR CLERKS

The Old Jewish Cemetery was preserved during the redevelopment of Josefov and enclosed by a new wall. This incorporated a one-storey villa on the corner of Břehová Street, built in 1913–1914 and designed by Antonín Engel. The architect's schooling, under Josef Zítek in Prague and Otto Wagner in Vienna, is reflected in the classically-inspired modernist style, the shaping of the building into clear, geometrical volumes, and the sculpted gradation of its mass. Instead of ornamentation, in the interior Engel applied a cladding of high-quality black marble, terracotta tiles, and simple patterns. Engel had designed a neighbouring apartment building for the Cooperative for the Construction of Rental Houses for Clerks in 1910, implementing the views he had published in an article in the magazine, *Style*. There, he declared that the disgusting pseudo-grandeur of apartment buildings must be offset by the sober yet authentic shape of the residences' exterior, accentuating constructive features, or even surface decoration, which however must always harmonise with the tectonic nature of the used materials. These views marked the end of the era of decorative Art Nouveau.

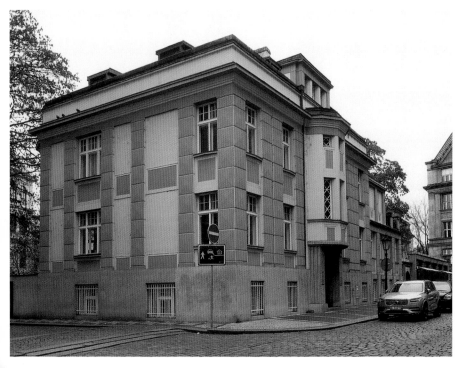

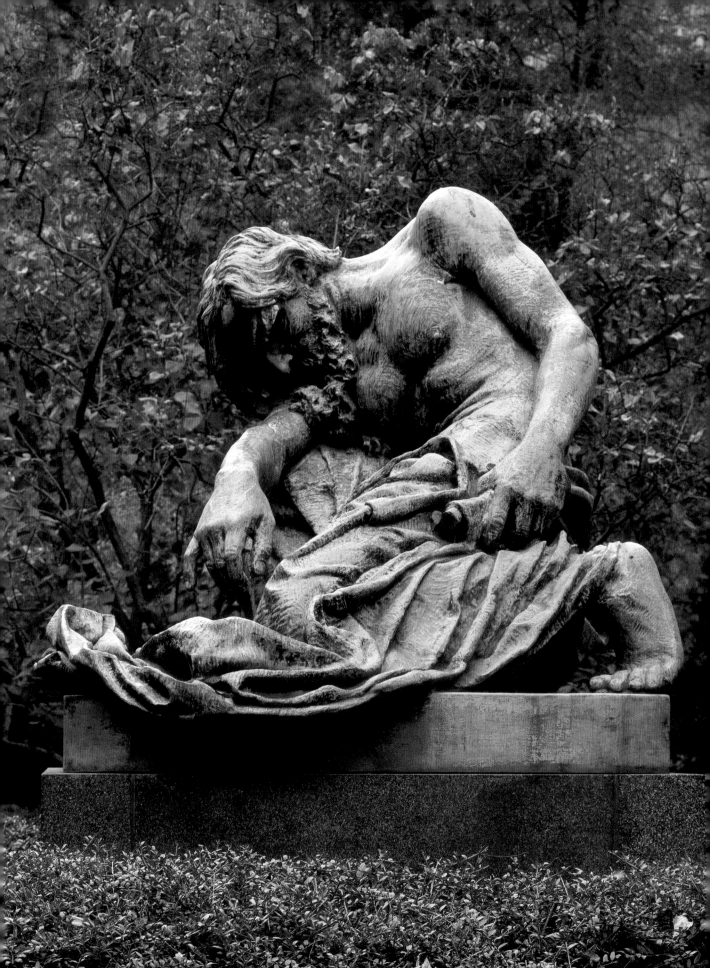

12/ FRANTIŠEK BÍLEK: MOSES

This representative of Czech symbolism depicted in 1904 the Old Testament prophet Moses, meditating over the scroll bearing the name of the biblical first man, Adam. Although the figure's stylisation is based on neo-baroque sentiments, it also bears elements of Art Nouveau, particularly the enclosure of the overall silhouette of the sculpture, expressing the theme of a dramatic inner concentration. The statue was originally placed outside the Old-New Synagogue, in the former centre of the Jewish ghetto in 1937. However, the regime during the German occupation had it removed in 1940. A new casting was returned to its original site after the war.

The statue of Moses is situated in a small, picturesque square, enclosed by the Old-New Synagogue and the outline of the old Jewish City Hall. To the side, the scenery is completed with apartment buildings on Meisel Street, built in 1910–1912, whose decoration reveals the growing preference for Biedermeier at that time.

13/ PAŘÍŽSKÁ AVENUE

The plan for Pařížská Avenue, originally Mikulášská Street, opening up a communication route from the Old Town Square to the Vltava River in the manner of Parisian boulevards, was the most radical intervention of the redevelopment to the urban structure of the Old Town. Its architecture was dominated by neo-baroque and eclectic expressions of romantic late historicism. The unprecedented width of the clearing through the old building blocks brought a new, metropolitan scale to Prague. At the present time, it is the most expensive location in Prague.

14A–B/ ŠTENC HOUSE

Kotěra's studio at the School of Decorative Arts was the seedbed of many young architects, of whom Otakar Novotný attracted attention by his design for the Jan Štenc graphic design company on Salvátorská Street in 1909–1911. In this he applied the aesthetics of exposed brickwork, inspired by Dutch and Anglo-American models. Novotný managed to bring together the specific technical and operational requirements for the building with feelings of intimacy and the high cultural character of the surroundings, associated with Czech art. In addition to other publications, he was primarily inspired by the art history oriented magazine, *Art* (1918–1949).

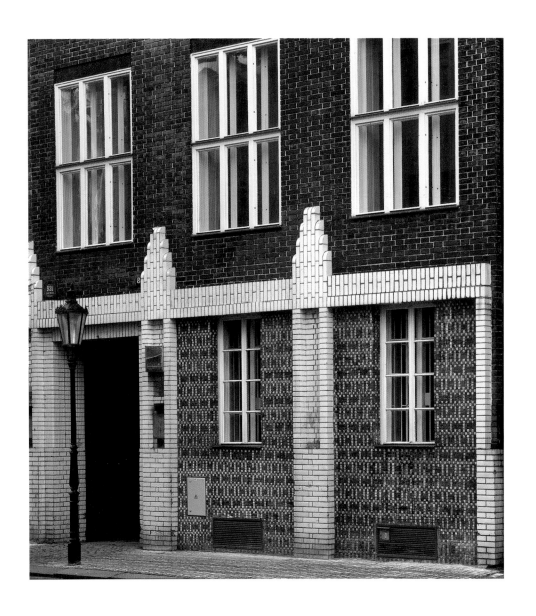

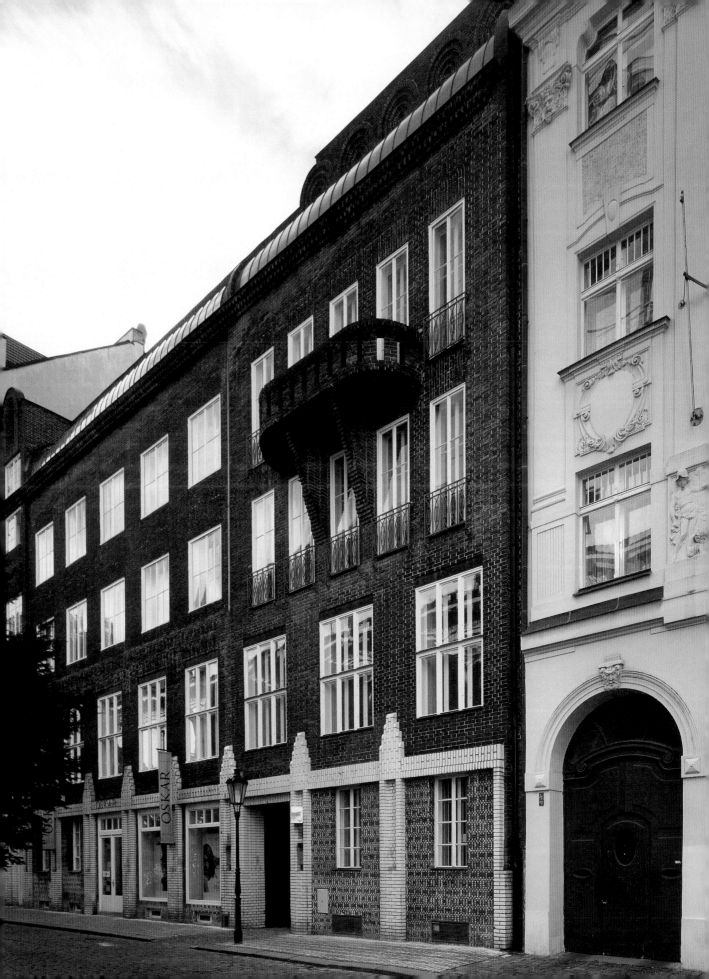

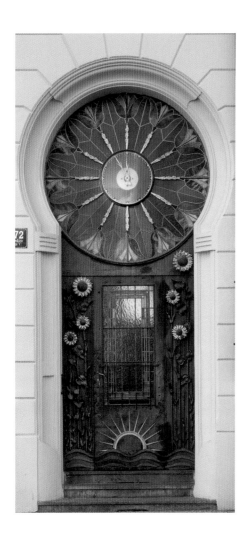

15A–C/ APARTMENT BUILDINGS ON HAŠTALSKÁ STREET

The large-scale redevelopment of Prague-Josefov made room for the construction of new apartment buildings, equipped with water pipes and sewage drains. This new standard of sanitation was metaphorically linked to the cult of nature, which was reflected in the floral ornamentation on the façades. An example of this trend can be seen in the buildings designed by Osvald Polívka on Haštalská Street at the very beginning of the 20th century. The symbolism of a plant in bloom, growing from a meditative mascaron, expresses the idea of the imperishability of life.

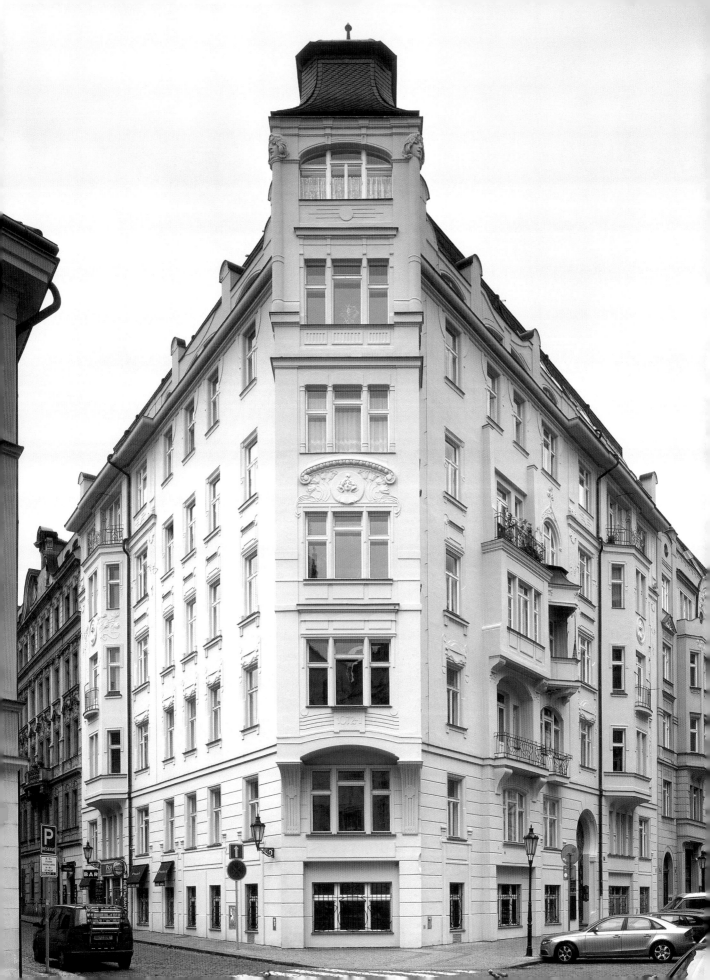

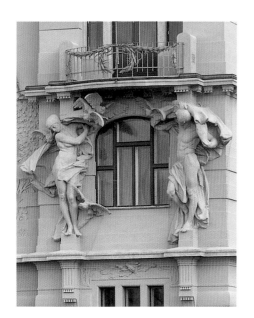

16A–C/ MAIN RAILWAY STATION

Originally called Franz Joseph I Station, the Main Station is, along with the Municipal House, another prominent Art Nouveau structure. It was built in 1901–1909 according to a design by Josef Fanta, to replace the older, classicist railway station whose plan, consisting of one central and two side pavilions, was retained. At its centre, Fanta incorporated the impressive element of a thermal window, opening into the high dome of the entrance hall, which is optically serried between two pylon towers. The remarkable richly-sculpted decoration was made by leading sculptors Stanislav Sucharda, Ladislav Šaloun, and Čeněk Vosmík. The metal structures of the platform halls, by engineers Jaroslav Marjanko and Rudolf Kornfeld, further contribute to the typical Art Nouveau impression as they represent the connection of ceremonial and utilitarian elements. The Imperial, later Presidential, Hall with murals by Viktor Stretti and Václav Jansa contributes to the harmony of the two elements.

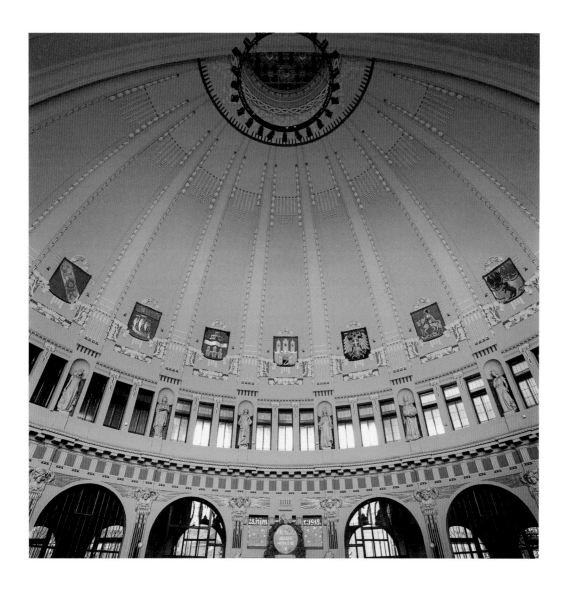

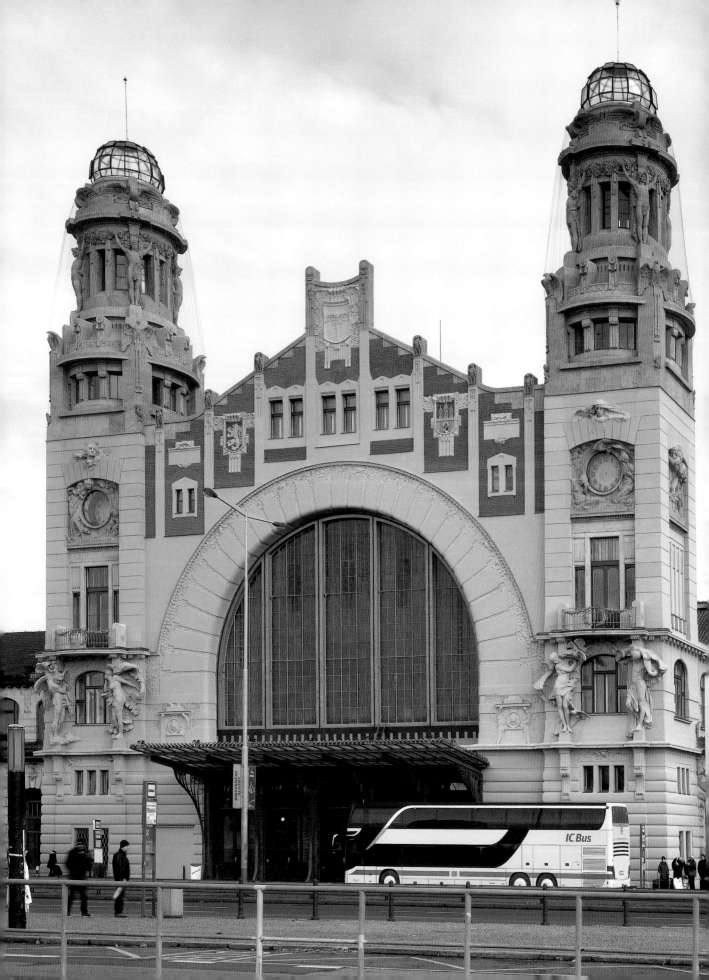

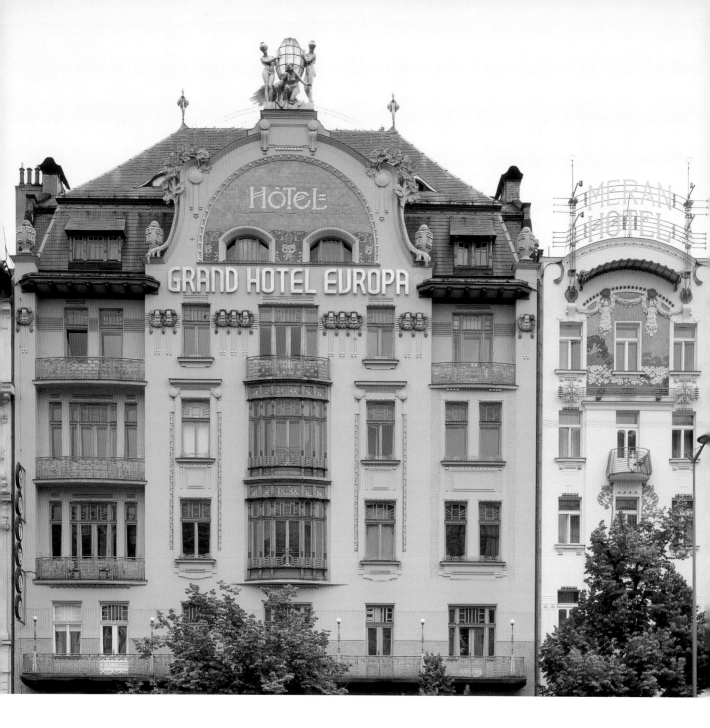

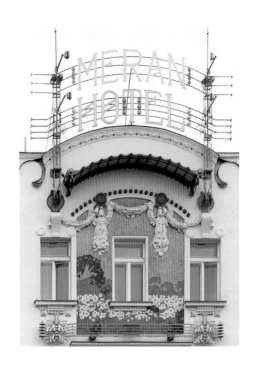

17A–C/ GRAND HOTEL EVROPA AND HOTEL MERAN
Excellent examples of hotel architecture, an important
genre of Art Nouveau in Prague, are Evropa Hotel
(originally Archduke Stephen Hotel) by Bedřich
Bendelmayer and Hotel Meran by Alois Dryák, built next
to each other on Wenceslas Square in 1903–1905. The
main elevations of the hotels form a visual unit, which is
interesting for its vivid asymmetry. The effect is further
enhanced by the delicate colours of the façades, decorated
by mosaics, floral wreaths and, crowning all, a gilded
group of female nudes holding a crystal-shaped lantern
by sculptor Ladislav Šaloun. The preserved interior
(by Bendelmayer) is also valuable – with a two-storey
café, a French restaurant, and a staircase in the style. The
geometric character of the decoration demonstrates its
Viennese inspiration, in which Bendelmayer and Dryák
followed their teacher, Friedrich Ohmann.

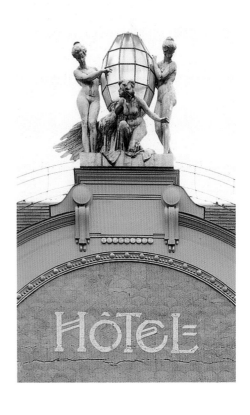

18A–B/ ICE PALACE

Striking evidence of the fading Art Nouveau ornamentalism is the corner building no. 795 (also called "the Ice Palace"), built on Wenceslas Square in 1913–1915 by Matěj Blecha's construction company, to a scheme by an unknown designer and decorator (perhaps Emil Králíček and Bohumil Waigant). It is an example of the typical interrelation between the rational building's plan and its decor, whose exaggeration leans towards expressionism.

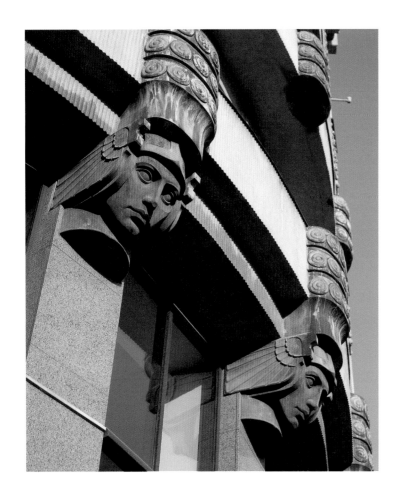

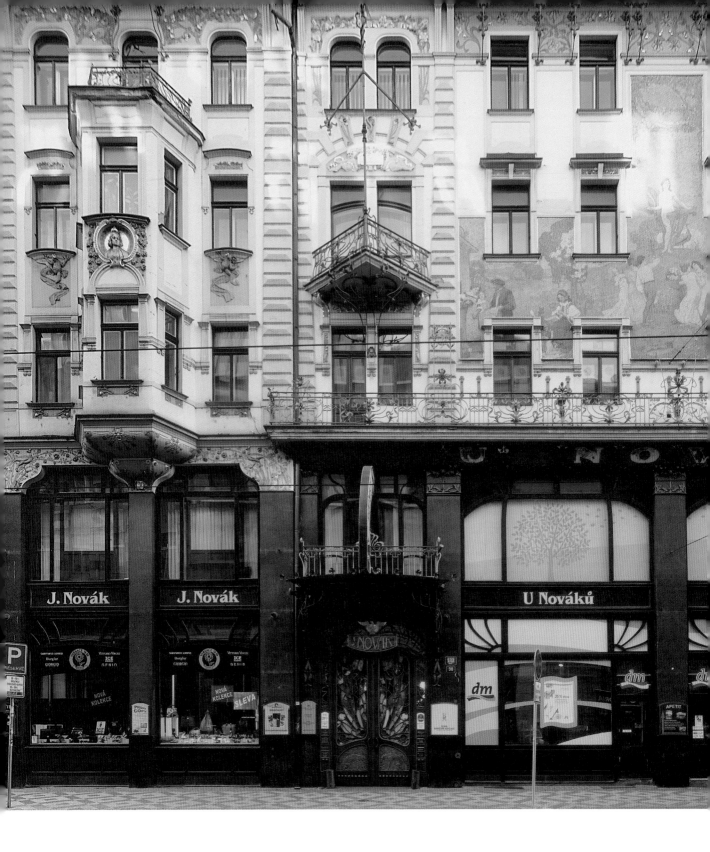

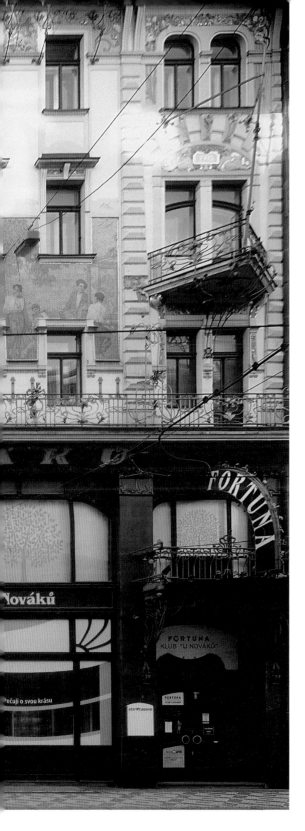

19A–B/ U NOVÁKŮ DEPARTMENT STORE

The original interior of the Novák Department Store on Vodičkova Street, built in 1902–1903 to a design by Osvald Polívka, offered a spacious hall, suitable for modern commercial purposes, although the current interior has been significantly altered. The exterior is a blaze of colours and fantastic, fairy-tale motifs in stucco. Also extraordinary are the proportion and the high-quality craftsmanship of the metal parts, grilles, and the entrance door decorated with coloured glass. The dominating feature of the main elevation is a large mosaic, designed by Jan Preisler, linking the folk motifs with the celebration of spring.

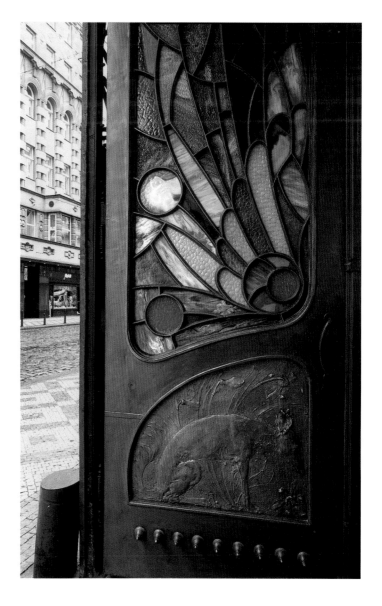

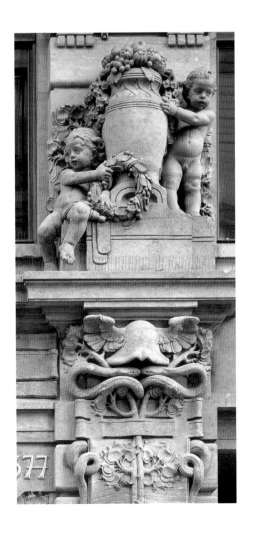

20A–C/ PRAGUE CREDIT BANK

When the imposing stone façade of the Prague Credit Bank on 28. října Street was made in 1902, Art Nouveau was already established in Prague as a modern decorative style. This achievement can be merited to its author Celda Klouček, professor at the School of Decorative Arts in Prague, whose studio was officially awarded as early as 1900 at the Paris World's Fair. The façade clearly shows how Prague Art Nouveau, as was typical for the style, transformed the older ornaments and enriched them through an emphasis on the soft undulation of shapes. The dominating feature on the attic gable is a statue of Mercury. The building was constructed by the enterprising company owned by Matěj Blecha.

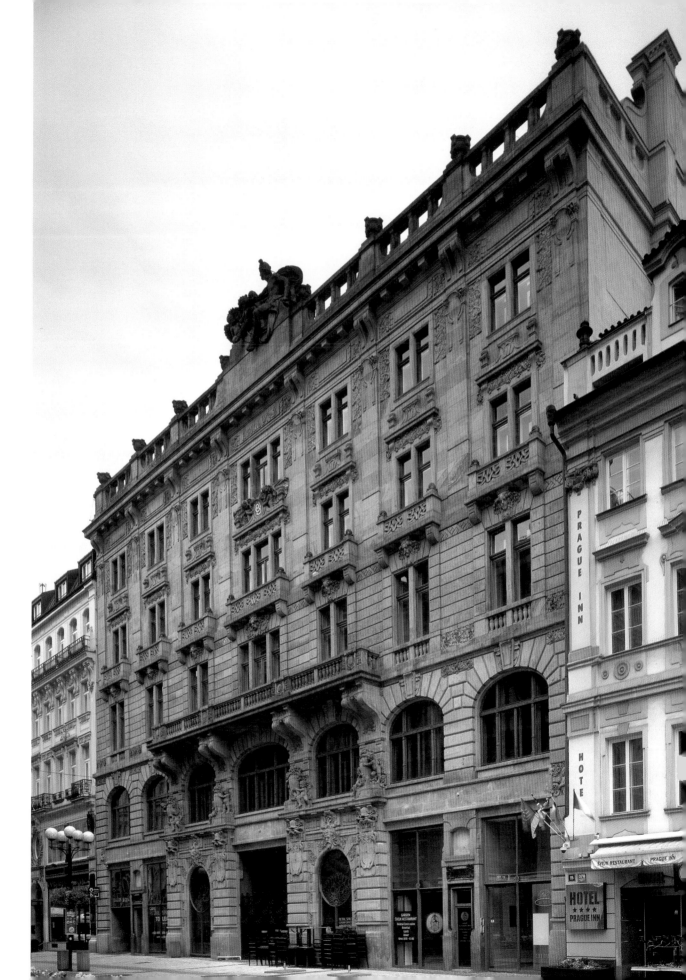

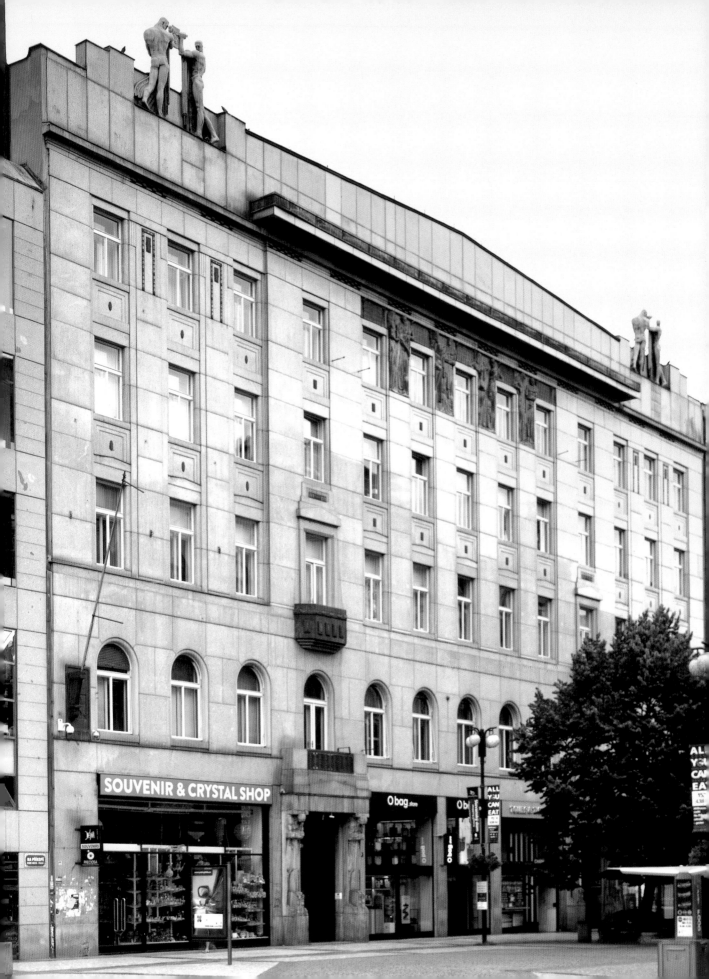

21A–B/ THE VIENNESE BANK ASSOCIATION PALACE

In 1906–1908, the prestigious Na Příkopě Street was enriched by a building which served as a reminder of the important ethnic German minority who lived and worked in Prague. The Viennese Bank Association Palace (Wiener Bankverein) was designed by Czech German Josef Zasche and decorated by Franz Metzner, from the Sudetenland. The interiors were designed by Austrian architect Alexander von Neumann. This building's style was radically different from the naturalist and traditionalist tendencies of Czech Art Nouveau. The smooth granite surface and the unusual stylisation of the sculptures recalled modern Vienna, which was to have a further and escalating influence on Czech architecture.

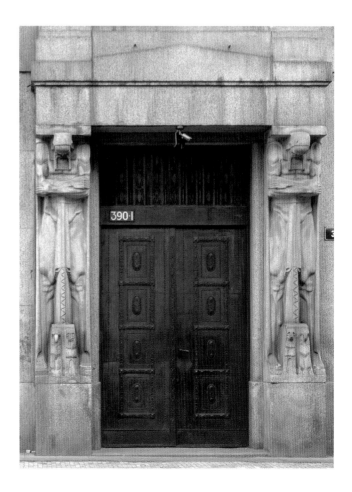

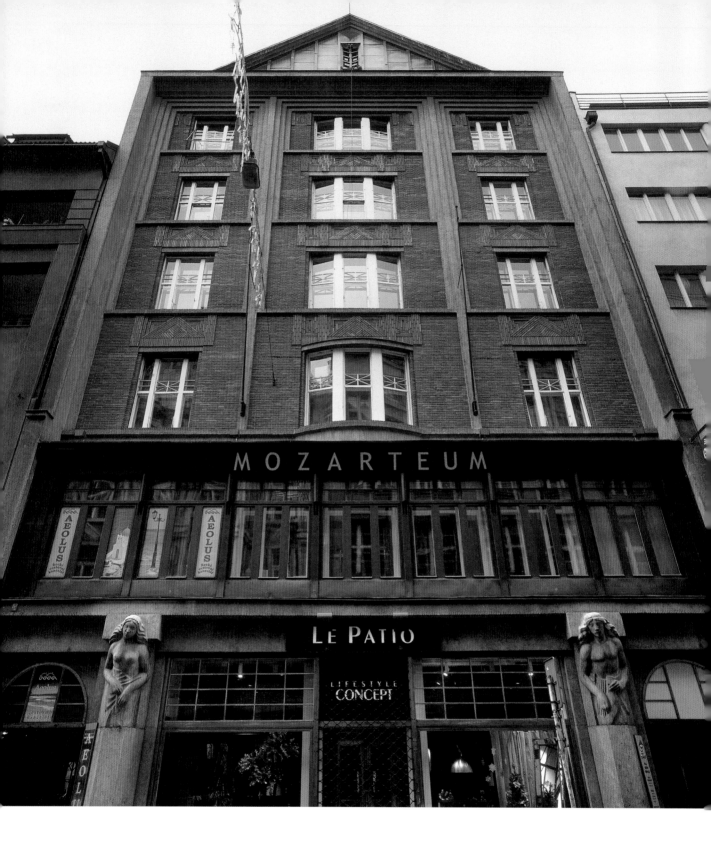

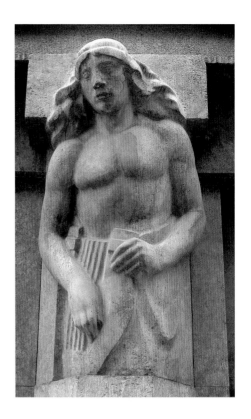

22A–C/ THE MOZARTEUM

A mature solution for an apartment building in the spirit of the new aesthetics is the house of the music publisher Mojmír Urbánek (the Mozarteum) on Jungmannova Street, designed by Jan Kotěra in 1911–1912. The triangular gable and distinctive rectangular framing by cornices clearly express the principle of connecting modern, hygienic, and functionally oriented rationality with classical taste. The integration of Jan Štursa's sculptures further develops this idea, while retaining the symbolist Orphean theme. There was also a concert hall in the building, reflecting its role as an important cultural centre. After remodelling, in the 1930s, it was the venue for Emil František Burian's D 34 Theatre and it also hosted exhibitions of avant-garde art.

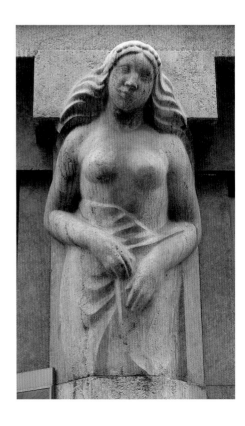

The promenade of Ferdinand Avenue, today National
Avenue, was enhanced in 1905–1907 by the reconstruction
of two neighbouring Empire style houses, after designs
by Osvald Polívka. Publisher František Topič bought the
house on the right and restarted the activities of the Topič
Salon, an exhibition hall, which he had originally operated
in the house on the left and which hosted many important
exhibitions of modern art between 1894 and 1899.

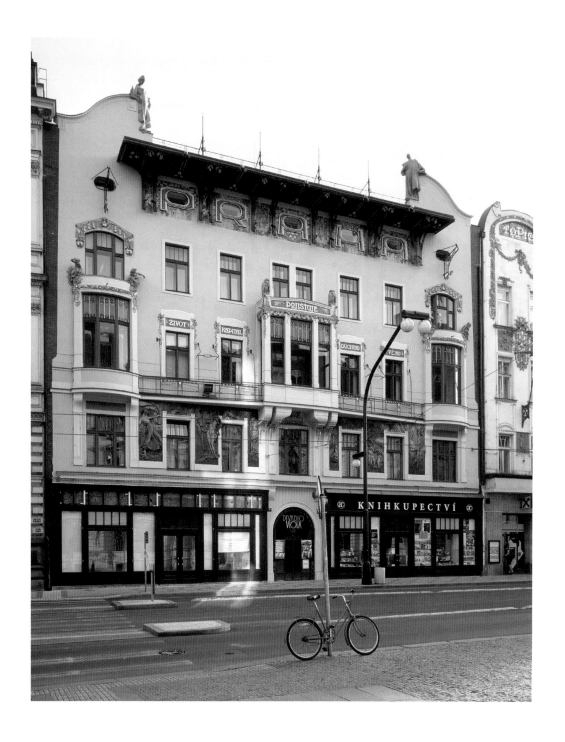

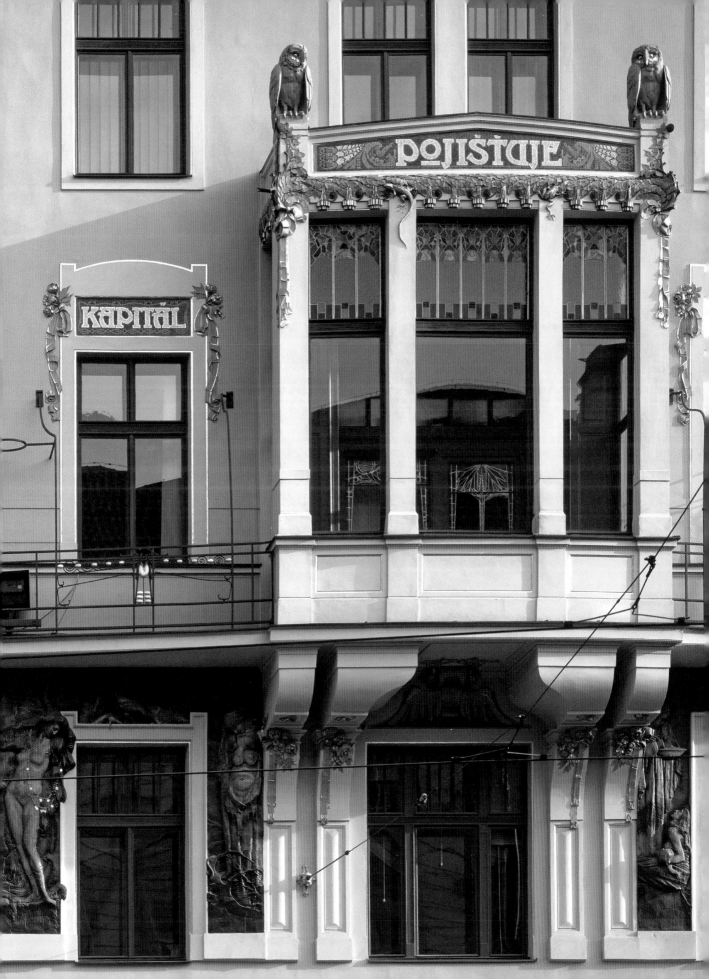

The new Topič House was designed by the architect to display the classical symmetry of materials. Its decoration consists of regularly inlaid figural reliefs, floral wreaths and garlands, and colours that do not overwhelm the light wall surface. Polívka, however, rejected such moderation when designing the neighbouring Praha Insurance Company building, dominated by an exuberant, protruding main cornice, which overhangs the rich colour decoration. Polívka's favourite fairy-tale motifs are complemented by statues of girls and an old man by František Rous, and a band of large, coloured ceramic reliefs by Ladislav Šaloun, inspired by the building's function. The colourful poster-like style of the Praha Insurance Company and the moderation of the Topič House suggest that the architect strove to counterpoise the neighbouring houses as female and male elements.

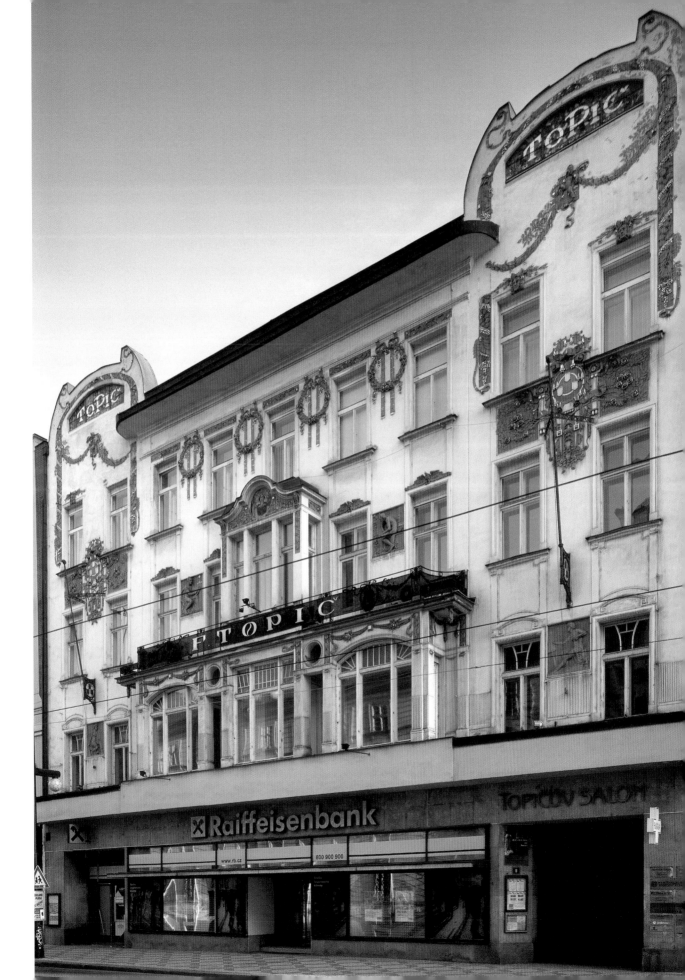

25/ APARTMENT BUILDINGS ON MASARYK EMBAKMENT

The Masaryk Embankment, forming a new communication route on the river's right bank in the area originally filled with houses and mills, was created after the slum clearance of the Vojtěšská Quarter, part of Prague's New Town. During 1903–1907, a picturesque set of apartment buildings, characterised by the mixing of historical and Art Nouveau styles, was built. The block begins behind the National Theatre with the Reinsurance Bank building (today's Goethe Institute), designed by Jiří Stibral, head of the School of Decorative Arts in Prague, with distinctive statues by Ladislav Šaloun. Other buildings that stand out include architect Kamil Hilbert's own house and the building of the Hlahol Choir Society.

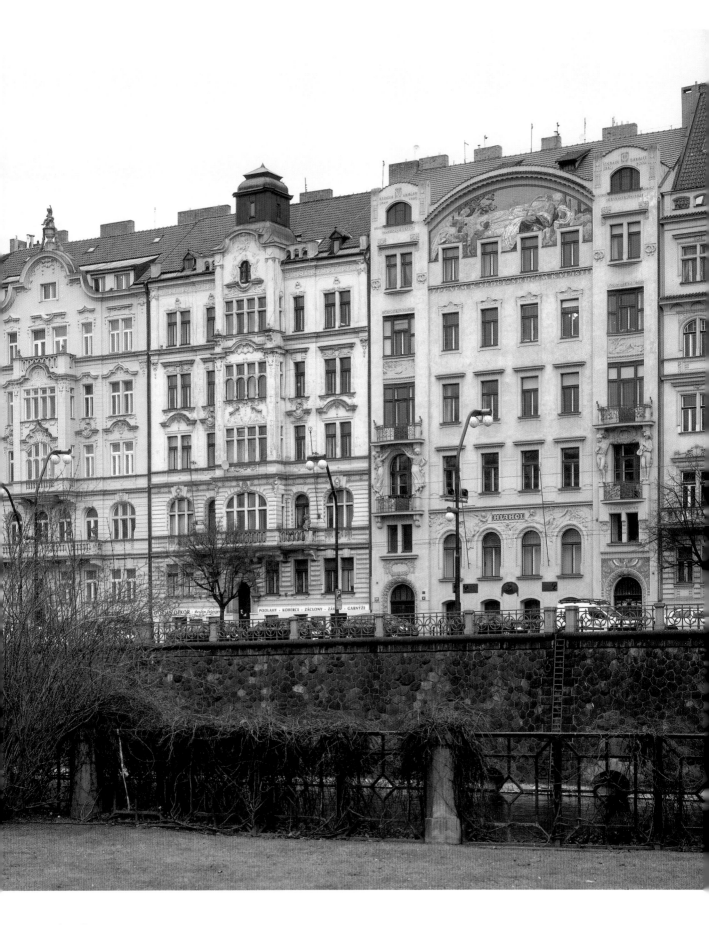

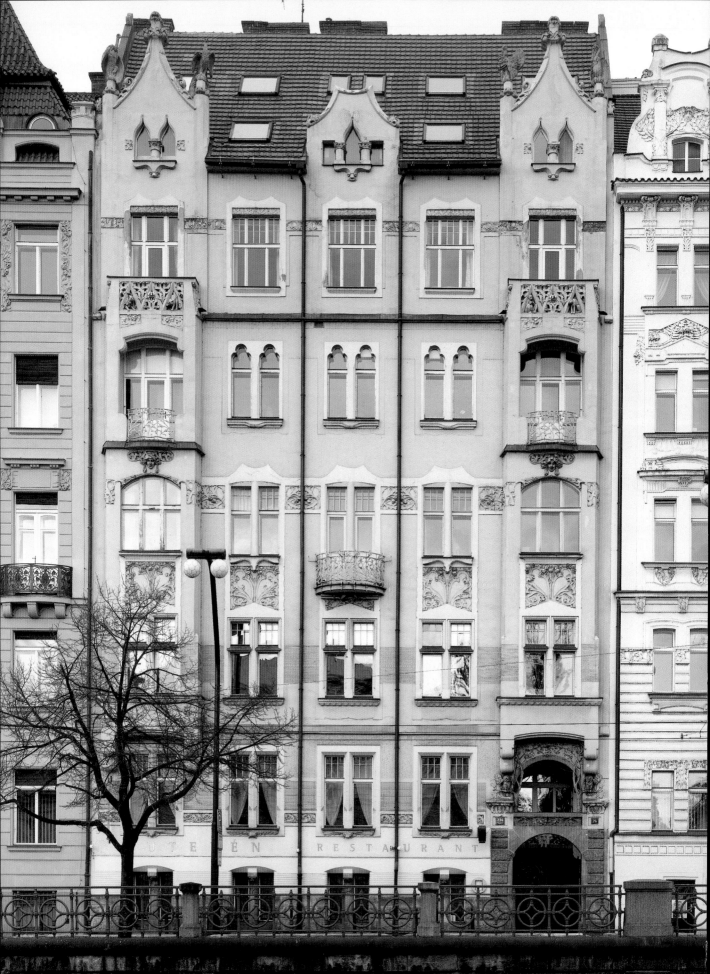

26A–C/ HILBERT HOUSE

Architect Kamil Hilbert, who supervised the completion
of St. Vitus Cathedral in Prague Castle, designed his own
apartment building on Masaryk Embankment in 1904–1905.
It is interesting for the combination of Art Nouveau and
late Gothic motifs. This impression is further enhanced by
the sculpted decoration by Karel Novák, a student of Celda
Klouček, complete with grotesque owls, squirrels, a water
goblin, and insect masks. Quite impressive also are the
stained-glass windows above the entrance to the courtyard.

27A–B/ HLAHOL CHOIR SOCIETY BUILDING

The building for the Hlahol Choir Society, which was an important Czech cultural institution from the 1860s, is located on Masaryk Embankment. Designed by Josef Fanta, it was built in 1904–1905. The richly ornamented façade is covered with sculpted decoration designed by Josef Václav Pekárek and ornaments by Karel Mottl. The gable contains a painting on ceramics representing an allegory of Music and designed by Karel Ludvík Klusáček. The entrance is adorned by a mosaic representing a phoenix and featuring the date of the building's completion. The courtyard contains a concert hall with preserved Art Nouveau furnishings, paintings by Klusáček, and an allegorical lunette of *Song* by Alphonse Mucha from 1934. The rear elevation of this double building, facing Vojtěšská Street, is richly decorated with sgrafitto, again designed by Klusáček, and other ornamental elements.

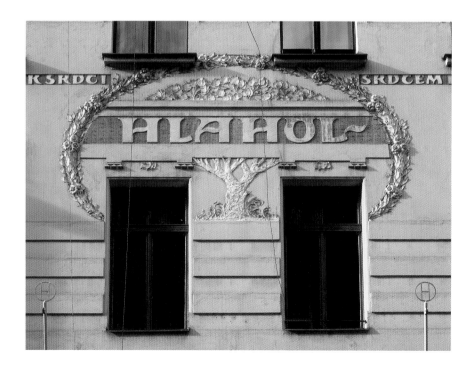

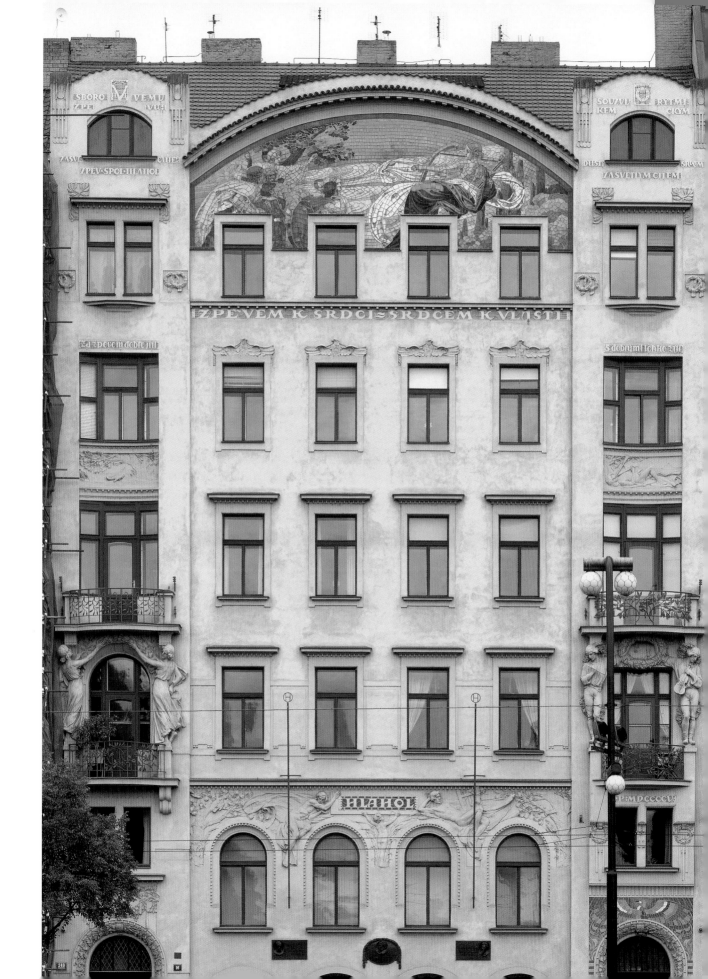

28A–C/ FRANTIŠEK PALACKÝ MONUMENT

Among the major manifestations of the Czech nationalist agenda at the turn of the 20th century was the erection of monuments to heroes of Czech history and important celebrities. The one most in keeping with Art Nouveau is the monument dedicated to the historian and national politician František Palacký, made in 1898–1912 by sculptor Stanislav Sucharda and situated in Palacký Square, in front of the eponymous bridge. The monument's theme is the popular apotheosis of the Czech nation, rising from its disastrous historical subjugation. The central figural group is twelve metres high. Sucharda's artistic patron for this dramatic monument was the French sculptor, Auguste Rodin. The unveiling of the monument in 1912 was a great national event.

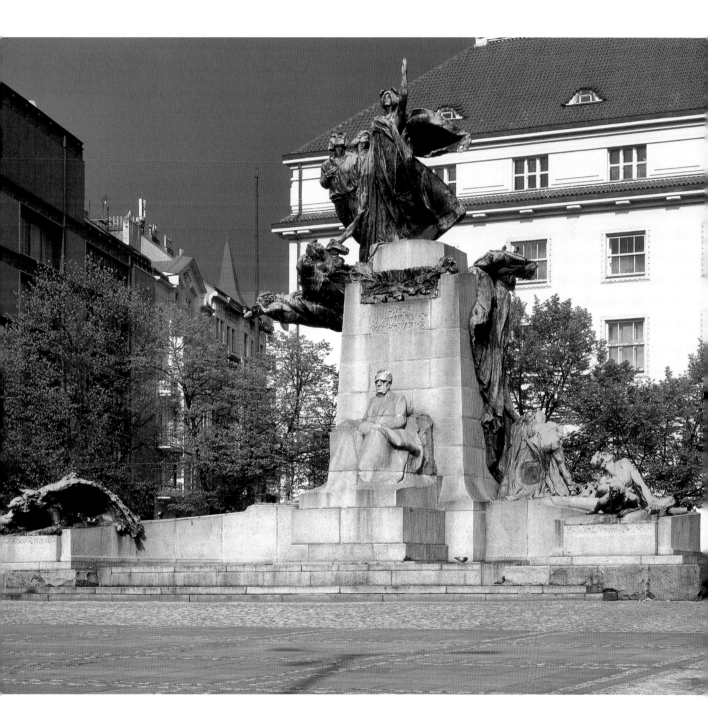

29A–B/ BUILDINGS AT THE FOOT
OF THE VYŠEHRAD ROCK
The boring of the Vyšehrad tunnel in 1902–1905 and
the subsequent construction of the embankment between
the Railway Bridge and the Vyšehrad rock paved the
way for the construction of new houses. Those built
between 1912 and 1913 are an interesting example of the
differentiation in modern architecture in Prague, which was
undergoing a significant stylistic transformation at the time.

29A/ **Villa Na Libušince**, designed by Emil Králíček for
medical doctor Vojtěch Mrázek, has classically designed
volumes topped by triangular gables and segmented by
shallow flat pilasters with volutes, although other details
are in the style of geometrical Art Nouveau. The main
façade and building decoration were made in collaboration
with sculptor Antonín Waigant.

29B/ **The Kovařovič Villa**, designed by architect Josef Chochol for builder Bedřich Kovařovič, is cubist. This is evident particularly in the dynamics of the façade facing the garden, which in its crystalline composition of oblique surfaces appears as if turning towards passers-by. The original fence perpetuates the style as well. Although the elevation facing the street is less dynamic, it also exhibits strong, sculpted geometrical forms.

Other buildings at the foot of Vyšehrad also designed by Josef Chochol – namely the triplex house on Rašínovo Embankment nos. 6, 8, and 10, and an apartment building on Neklanova Street no. 30 – conclude this turbulent chapter of the development of Prague's modern architecture, which was launched by the appearance of the Art Nouveau style. They are manifestations of the youngest architects' will to completely free themselves from the commitment to ornamentation and to focus on the three-dimensional structure of the core building itself. The dynamic concept and abstract geometrical surfaces reflect the fundamental idea of social and aesthetic architectural activity that had been initiated by the authentic Art Nouveau style.

30A–E/ VYŠEHRAD – SLAVÍN AND JOSEF VÁCLAV MYSLBEK'S SCULPTURAL GROUP

In Vyšehrad, permeated by the myths and legends of the origins of the Czech principality, near the re-Gothicised Basilica of St. Peter and St. Paul, are situated the cemetery and the national tomb of Slavín. The latter was completed in 1893, under the direction of architect Antonín Wiehl and sculptor Josef Mauder. The arcades and the entire area of the cemetery feature many outstanding tombstones designed by leading Czech sculptors of the Art Nouveau period, including Bohumil Kafka, Ladislav Šaloun, František Bílek, and Stanislav Sucharda.

The large stone sculptural groups by Josef Václav Myslbek, situated in the park, represent four pairs of mythical figures from the period of the early Přemyslid dynasty: Prince Přemysl and Princess Libuše, prophesying the glory of Prague; the bard Lumír and the Song; the victorious warriors Záboj and Slavoj; and Ctirad and Šárka, from the romantic episode of the tale of The Maidens' War. The themes are adopted from the Dvůr Králové Manuscript, a famous forgery from the era of the Czech National Revival. The statues, sculpted in the 1890s, were originally made for Palacký Bridge, but after it was damaged in air raids during World War II and subsequently reconstructed, they were moved to Vyšehrad.

J. V. Myslbek: *Ctirad and Šárka*

J. V. Myslbek: *Libuše and Přemysl*

J. V. Myslbek: *Záboj and Slavoj*

Slavín

31/ TRMAL VILLA

One of the guiding principles of the Art Nouveau lifestyle was the intimacy of family life. The villa built in Strašnice for the headmaster of the public business school, František Trmal, constructed in 1902–1903 by Jan Kotěra, has all the prerequisites to meet this demand. The roof shape evokes the desire for a connection to folk timbre architecture.

The decorative colour also relates to this inspiration, while modernity is apparent in the ornaments' stylisation and in the modern, functional plan of this suburban villa.

(143)

Young Jan Kotěra's lyrical style is apparent in the fanciful
shapes of the columns and grillwork of the Robitschek
tomb, made in 1902 in the New Jewish Cemetery on the
border of Prague's districts of Vinohrady and Žižkov.
The neighbouring Elbogen's tomb, however, indicates that
Kotěra was not alien to the purism of non-ornamental
forms. This polarity of expression was to govern the general
development of modern architecture at the time. Even so,
the Art Nouveau melancholy enabled this style to create
an interesting array of funeral architecture in Prague's
cemeteries.

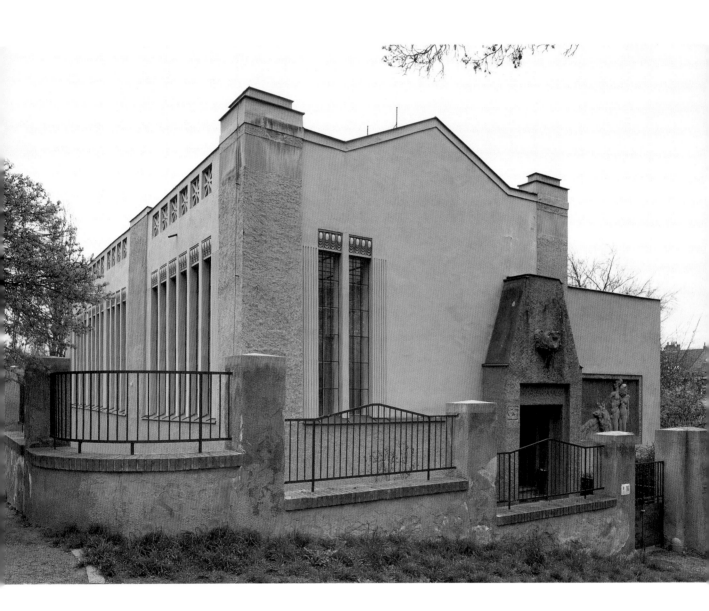

ŠALOUN STUDIO

A studio for sculptor Ladislav Šaloun, who contributed
to Prague's exteriors through many decorations and
monuments, was built in 1910–1911 on the southern slope
of Prague-Vinohrady. The simple prism of the studio's
main hall is attached to the entranceway, decorated with
a unique mascaron, a cryptic portrait of the philosopher
Arthur Schopenhauer, and an allegorical relief inspired
by Friedrich Nietzsche.

34/ KOTĚRA VILLA

In 1908–1909, architect Jan Kotěra built his own villa on Hradešínská Street in Vinohrady. The dominating feature of the building is a prismatic tower with a flat roof, which contained Kotěra's design studio, while other parts of the building are in simple geometrical shapes. The earlier ornamental decor was replaced by an aesthetics of the materials themselves, of which the exposed brickwork was becoming a typical feature of the style's turn towards "individualised modernism."

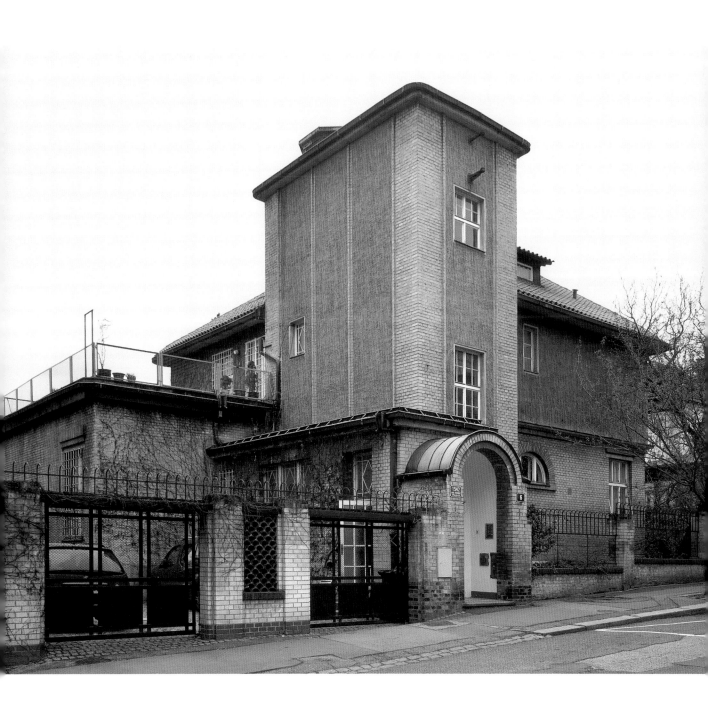

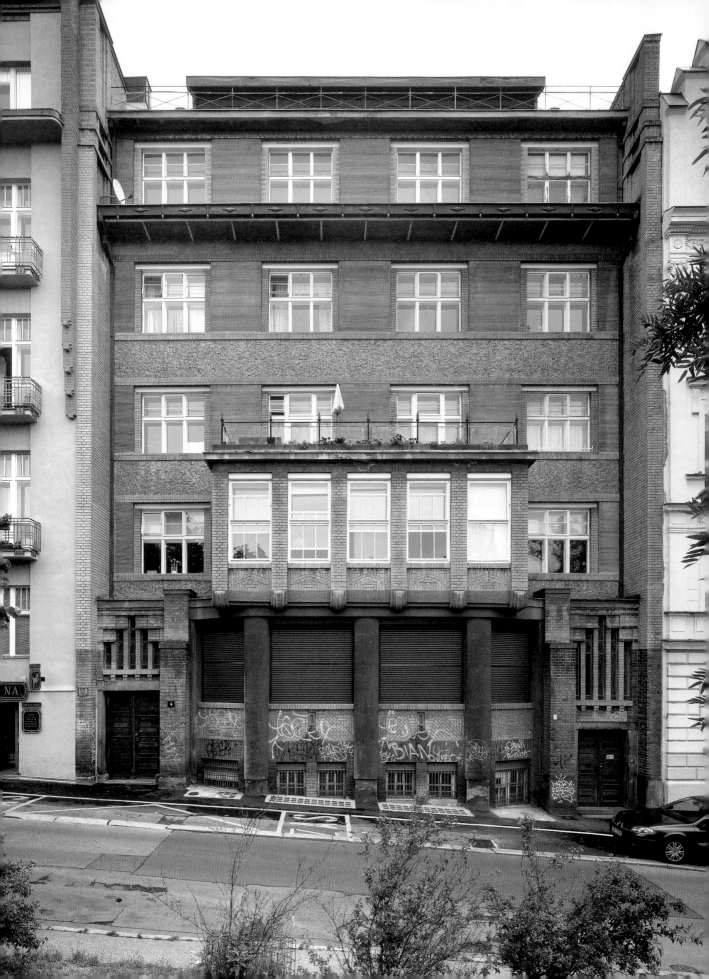

In 1908–1909, Jan Kotěra built a house for the publisher Jan Laichter on Chopin Street in Prague-Vinohrady. This building heralded the new aesthetics, free of the earlier naturalist ornamentation, with that role assumed by interesting patterns of different coloured bricks, alternating with bands of roughcast, stone, wooden, and metal details. The new concept of artistically accentuated geometric surfaces is displayed in the preserved interior stair hall, excelling in the elegant new taste.

36A–B/ SVATOPLUK ČECH BRIDGE

The boulevard of Pařížská Avenue, which stretches from the Old Town Square to the Vltava River, was built during the slum clearance in Prague-Josefov. It was proposed that the city expansion to Letná would continue across the river via a bridge. The bridge, named after poet Svatopluk Čech, was built in 1906–1908 according to a design by Jan Koula, working in cooperation with engineers Jiří Soukup and František Mencl. Malleable iron provided an opportunity to crown this civil engineering achievement with rich figural and ornamental decoration, created by Karel Opatrný, Antonín Popp, and Ludvík Wurzel.

37/ HANAU PAVILLION

Part of the General Land Centennial Exhibition was also the tiny building of Hanau Pavilion, designed by Otto Hieser and Josef Hercík, adorned by Zdeněk E. Fiala, and promoting the products of Duke Wilhelm Hanau's steelworks in Komárov near Hořovice. The fanciful assemblage of elements drawing on the Dutch baroque creates a playful structure. The current location of the pavilion in Letná Park intensifies the building's poetic effect.

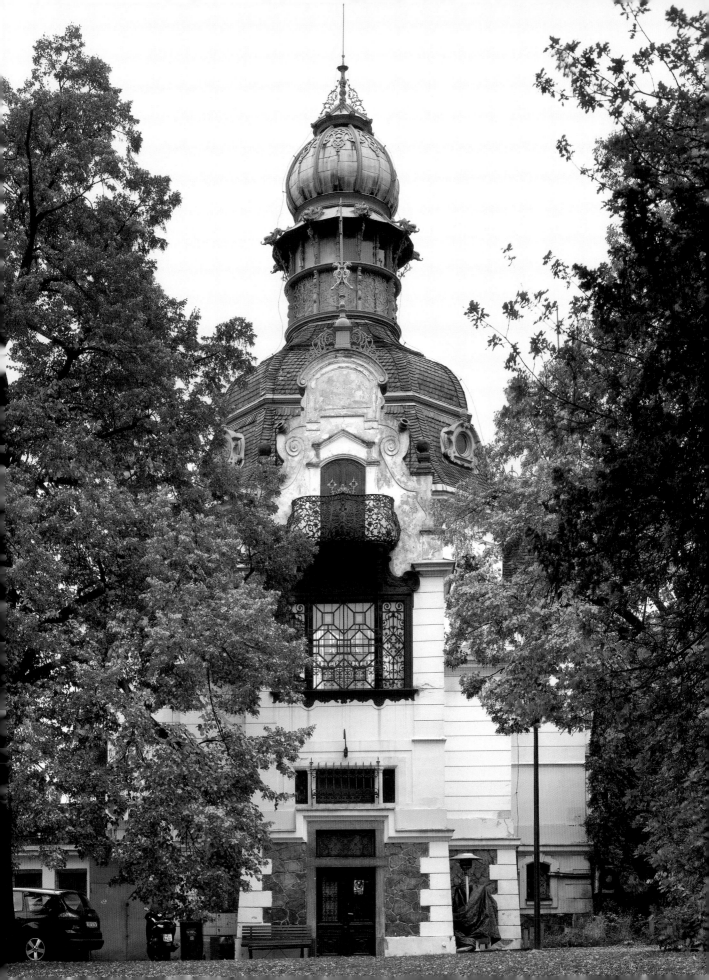

38/ KRAMÁŘ VILLA

This impressive villa, situated on a prominent empty plot of the Hradčany bastion and visible from a distance, was built for the renowned Czech politician Karel Kramář in 1911–1914. It was designed by architect Friedrich Ohmann, at the time a professor at the Academy of Arts in Vienna, whom Kramář met when Ohmann had worked at the School of Decorative Arts in Prague. Ohmann designed the building in the classicist baroque style, with a mansard roof and a portal on the south façade with a balcony bearing in grillwork the inscription "Fight for the truth, even if against all" and the year 1914. One year later, Kramář was arrested as a member of the Czech resistance movement and sentenced to death. Later, he was pardoned and became prime minister of the first Czechoslovak government in 1918–1919. The building's interior still contains some Art Nouveau decorative elements and attests to the taste of Kramář's Russian wife, Nadezhda Nikolayevna. The villa is currently owned by the state and serves as a residence for Czech prime ministers.

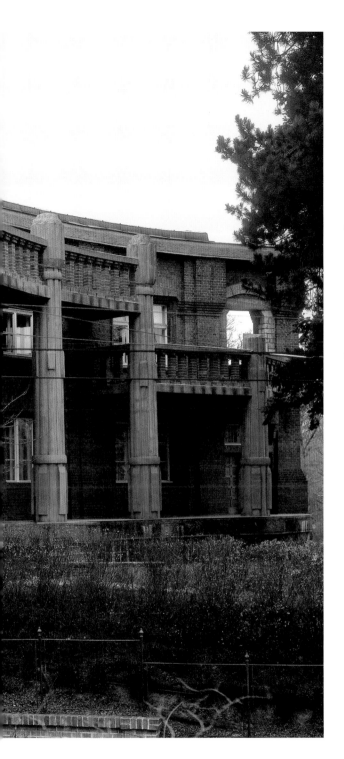

39A–F/ BÍLEK VILLA

The cultural importance of Art Nouveau for Prague is also highlighted by the villa-studios of notable artists. Sculptor František Bílek's brick building from 1910–1911 dominates the top end of Chotkova Street. Bílek designed his house himself using the symbolism of "life as a field full of ripe corn," which is reflected in the Ancient Egyptian-style columns and the flat roof. The residential area with original furniture, designed by Bílek, and his studio featuring outstanding examples of his symbolist work, are open to the public. Bílek's sculptural group representing Comenius bidding farewell to his homeland is situated outside the villa.

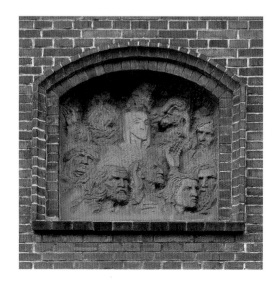

Views of Bílek's studio

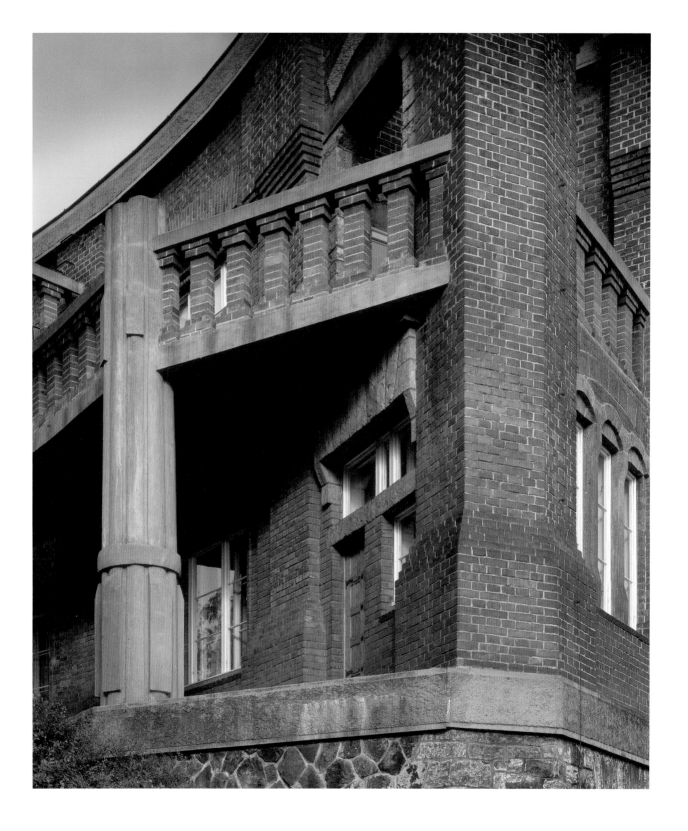

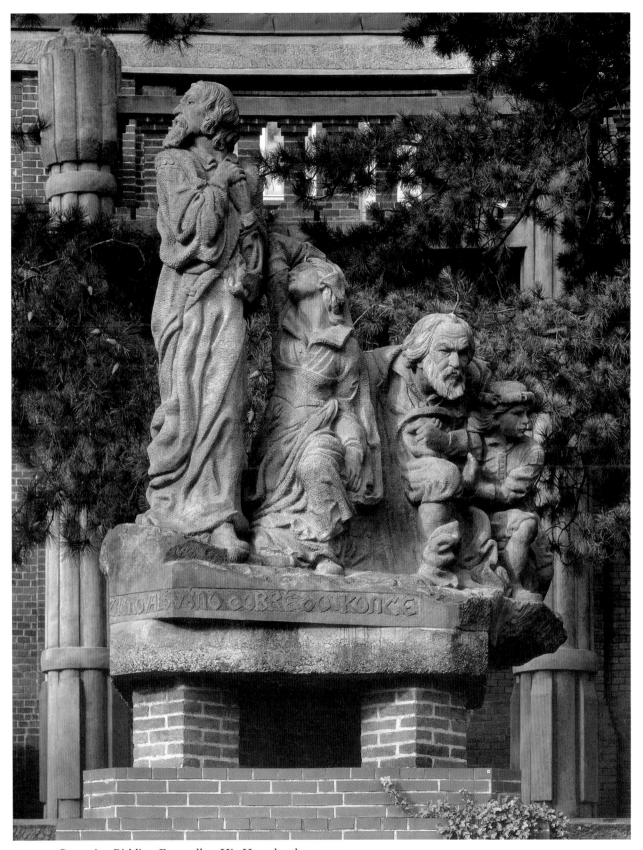

Comenius Bidding Farewell to His Homeland

40A–B/ WILFERT VILLA

This villa, built in 1904–1905 on the border of Letná Park, was likely designed by the prominent Sudeten German architect Josef Zasche, whose architectural expression in Prague drew on Viennese modernism. This is reflected in the geometrical and plain front façade of this large villa. Its sizeable central area, originally coloured grey-blue, is divided only by windows and modestly decorated by an ornamental stripe below the cornice. A remarkable colourful ceramic relief, resembling a sundial and depicting a standing figure of Virgin Mary and a saint, is situated between the first-floor windows. This decorative element indicates that the villa was built for Czech German artist Karel Wilfert Jr., whose studio was located in the attic. The relief is believed to be the work of Richard Teschner, who ran a private art-oriented school together with Wilfert.

41/ KOULA VILLA

Villa neighbourhoods were a typical urban expression of Art Nouveau and its endeavour to enhance city living and to express man's relationship to nature. A new group of modern artists' and architects' family houses was built in a previously undeveloped location in Prague-Bubeneč, around today's Slavíčkova Street. Architect and professor at the Czech Technical University, Jan Koula, designed villa no. 153 for himself in 1896. It was his response to widespread popular interest, stirred up in 1895 by the Czech and Slavic Ethnographic Exhibition held at the nearby exhibition grounds in Prague, where he presented his award-winning Czech wooden cottage. Koula studied preserved local folk structures and, in addition to architecture, he designed furniture, glass, ceramics, and embroidery patterns inspired by folk motifs. Moreover, he followed the efforts to create a new decorative style. His villa displays this inspiration particularly in the high-pitched gable roof with carved wooden slats, at the time considered to be typical of Slavic folk architecture. Koula decorated his house with a colourful sgraffito decoration. By the entrance, there is a niche with a statue of St. Ivan the Hermit by Stanislav Sucharda.

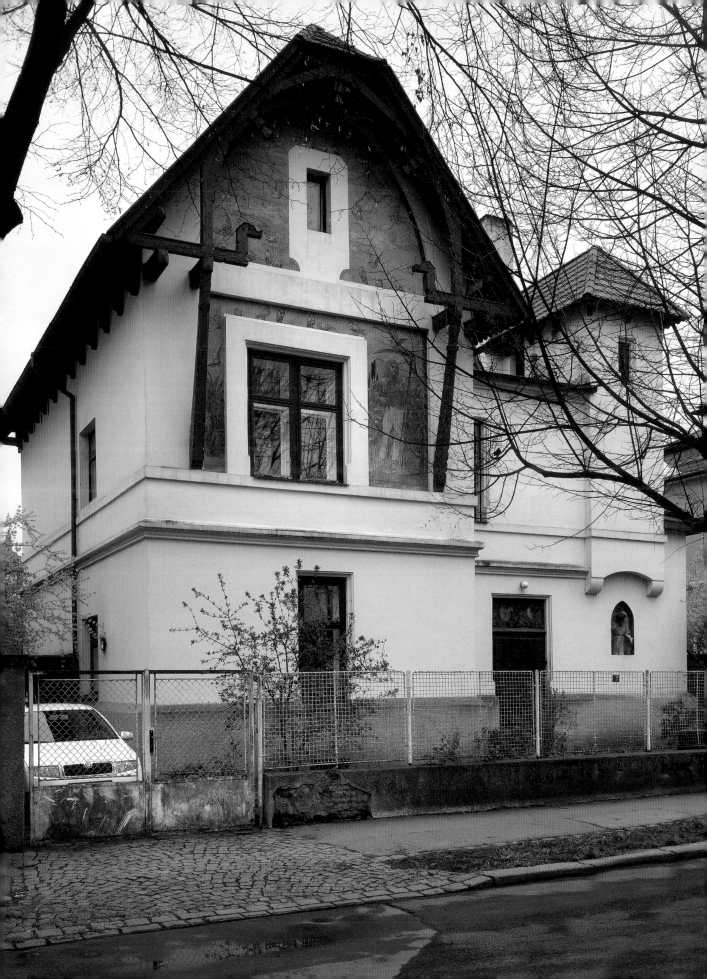

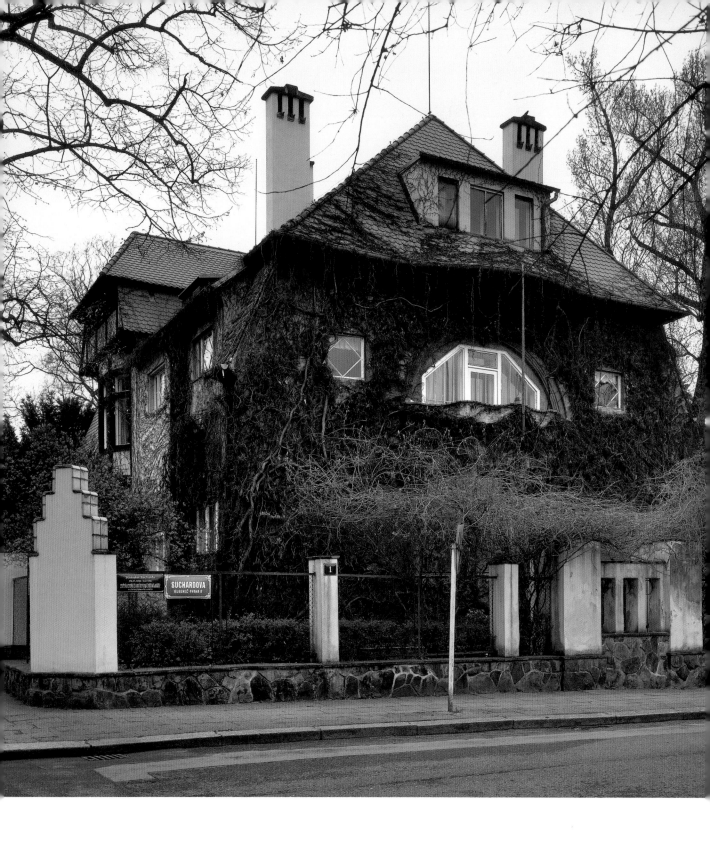

42A–B/ SUCHARDA VILLA

Sculptor Stanislav Sucharda was a professor at the
School of Decorative Arts in Prague and, as the long-
term president of the Mánes Association of Fine Artists,
also a leading representative of the Czech modern art
movement. After he won the competition for the monument
commemorating František Palacký in Prague in 1901, his
villa built in Prague-Bubeneč in 1896 ceased to satisfy his
needs. He built a new one, located on a nearby plot of
land, with an attached sculpture studio. The new villa was
designed by his friend from the Mánes Association and
colleague from the School of Decorative Arts, Jan Kotěra,
whose concept for the house made use of his knowledge
of the layout of an English house. The interior included
prominent artworks typical of Czech modernism.

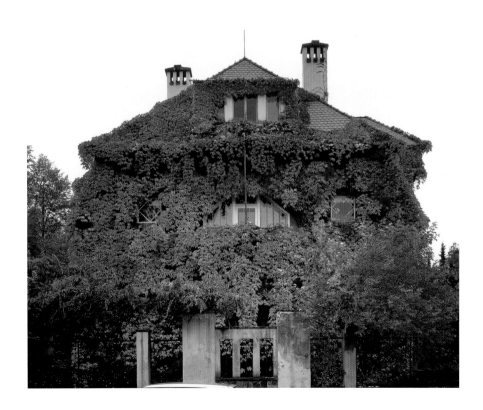

43/ MAŠEK VILLA

Painter and architect Karel Vítězslav Mašek's villa from 1901 is a good example of the vision of romantic utopias that was popular at the time. Mašek studied painting in Munich and Paris. In the 1890s, he became a professor of ornamental drawing at the School of Decorative Arts in Prague and designed decoration for many prominent buildings erected at the time (Praha Insurance Company building in 1895, the Main Post Office building in 1901). His villa was an example of a comprehensive work in this style, as Mašek was not only the building's architect but also designed all interior furnishings, which aimed to cultivate a family environment. The roof features wooden elements, inspired by folk architecture.

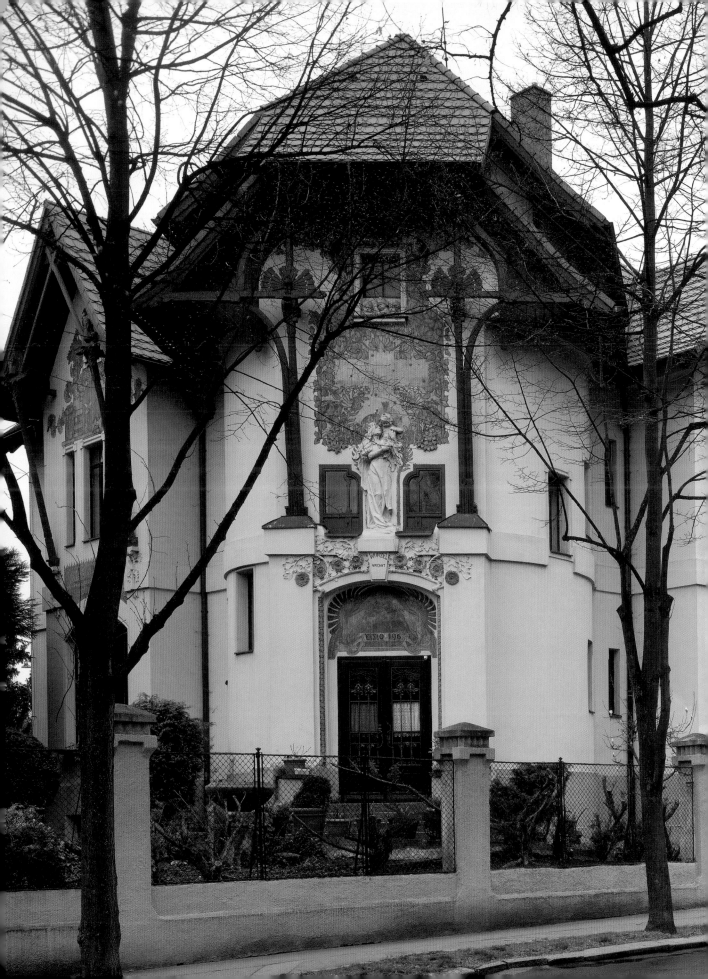

44/ NÁHLOVSKÝ VILLA

This villa, designed by Dušan Jurkovič for lawyer Jan Náhlovský in 1907, represents an original synthesis of folk and modern (specifically Viennese) elements. Slovak Jurkovič gained renown in the 1890s thanks to his wooden houses in Rathošť (Beskydy Mountains in Moravia) and spa buildings in Luhačovice (dating from 1902). The design of the villa in Prague was inspired by English houses, particularly the central two-storey hall, which is reflected on the exterior through the high gable in the middle section of the house. Lively colours are another typical feature.

45/ SIEBURGER VILLA

This large villa – commissioned by imperial councillor Hugo Sieburger, owner of a factory that produced furniture and decorative items – was designed by Bohumil Hübschmann and inspired by Viennese architectural modernism. This is reflected in the geometrical concept of the building, erected in 1908–1909, and the band of ornamentation that divides its modestly articulating exterior walls. The house, however, also features more romantic elements in the roof design and the carved junctions of the wooden beams. The villa was surrounded by a symmetrical garden with a pergola and an oval swimming pool.

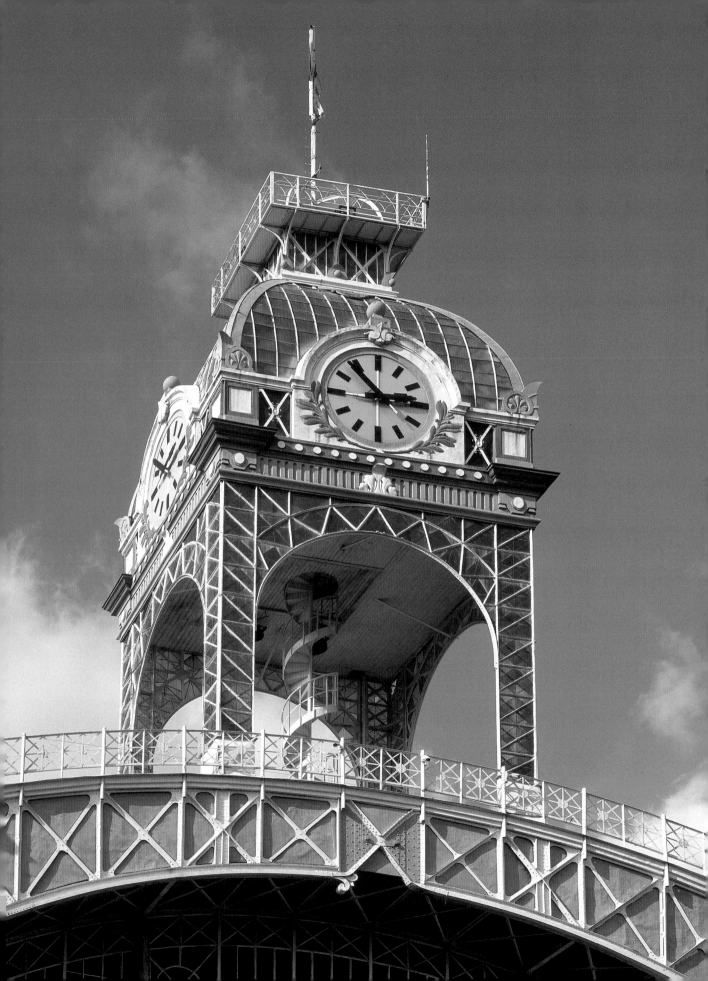

46A–B/ INDUSTRIAL PALACE

The Industrial Palace, designed by architect Bedřich Münzberger, was built in 1890–1891 at the exhibition grounds in Prague-Bubeneč as a landmark of the General Land Centennial Exhibition. It was an example of structuralist or "engineered" architecture, using a steel structure filled with glass instead of traditional masonry, which made it a symbol of modernity and progress. Some of its traditional historical ornaments have disappeared with only the neo-baroque decoration of the corner pylons remaining. The period of "socialist realism" supplemented the columns and figural decoration of the ground-floor entrance. An interesting original detail is the filigree-inspired spiral staircase ascending to the dome, which was originally topped with the Czech crown of St. Wenceslas.

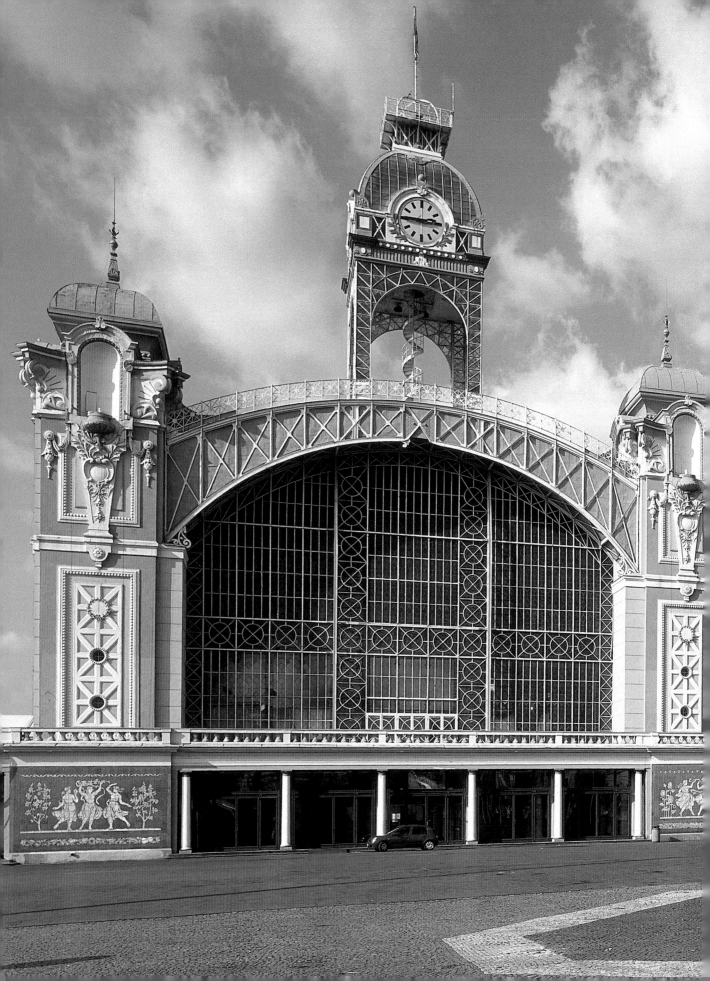

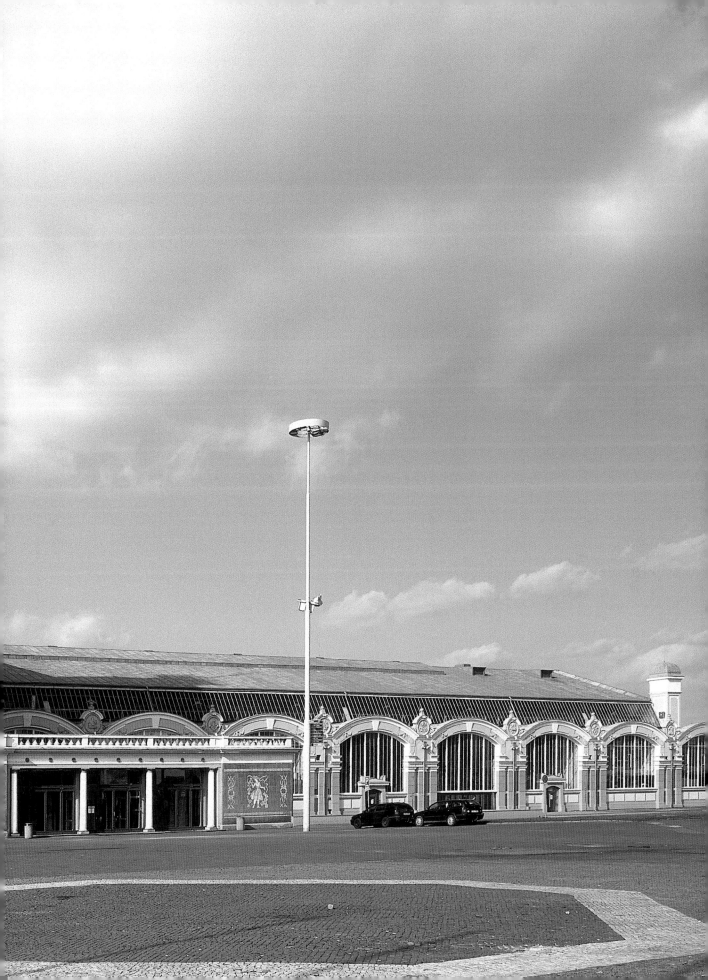

47A–B/ SEWAGE TREATMENT PLANT IN BUBENEČ

The construction of the sewage treatment plant in
1901–1906 was commissioned to the firm of Quido Bělský.
It was to be a culmination of the generous project of
the city sewerage system in Prague, whose construction
began in 1985 under the supervision of English engineer
W. H. Lindley. It demonstrates a positive amalgamation
of modern technology with an interesting yet functional
building design. This is reflected in the symmetrical
composition and the combination of white plaster and fair-
faced brickwork with rusticated corners in the middle tract
of the complex. The sewage treatment plant illustrates the
ability and intention of the Art Nouveau period to endow
even very practical works of architecture with aesthetic
qualities. The plant is now a technological monument and
an environmental museum.

EMINENT PERSONAGES

Aleš, Mikoláš (1852–1913), painter, draughtsman and illustrator
Balšánek, Antonín (1865–1921), architect
Barvitius, Antonín (1823–1901), architect
Bělský, Quido (1855–1909), architect
Bendelmayer, Bedřich (1872–1932), architect
Berlage, Hendrik Petrus (1856–1934), Dutch architect
Bílek, František (1872–1941), sculptor and graphic artist
Blecha, Matěj (1861–1919), architect and builder
Boudová, Anna (1870–1940), painter
Bourdelle, Émil Antoine (1861–1929), French sculptor
Čech, Svatopluk (1846–1908), poet and novelist
Dryák, Antonín (1872–1932), architect
Engel, Antonín (1879–1958), architect
Fanta, Josef (1856–1954), architect
Fialka, Jindřich (1855–1920), builder and architect
Folkmann, Hanuš (1876–1936), sculptor
Gočár, Josef (1880–1945), architect
Gutfreund, Otto (1889–1927), sculptor
Hercík, Josef (1849–1919), project designer
Hergesel, František, Jr. (1857–1929), sculptor
Hieser, Otto (dates unknown), architect
Hilbert, Kamil (1869–1933), architect
Hus, Jan (1371–1415), preacher and reformer
Hübschmann (Hypšman), Bohumil (1878–1961), architect
Chochol, Josef (1880–1956), architect
Jansa, Václav (1859–1913), painter
Jurkovič, Dušan (1868–1947), Slovak architect
Kafka, Bohumil (1878–1942), sculptor
Klouček, Celda (1855–1835), sculptor
Kotěra, Jan (1871–1923), architect
Koula, Jan (1855–1919), architect
Králíček, Emil (1877–1930), architect
Laichter, Jan (1858–1946), publisher and bookseller
Lindley, William Heerlein (1808–1900), English engineer
Marold, Luděk (1865–1898), painter
Mařatka, Josef (1874–1937), sculptor
Masaryk, Tomáš Garrigue (1850–1937), philosopher, politician, university professor, first Czechoslovak president
Mašek, Karel Vítězslav (1865–1927), painter
Metzner, Franz (1870–1919), sculptor
Mocker, Josef (1835–1899), architect
Mottl, Karel (dates unknown), builder
Mrštík, Vilém (1863–1912), writer and playwright
Mucha, Alphonse (1860–1939), painter, graphic artist and illustrator
Münzberger, Bedřich (1846–1928), architect
Myslbek, Josef Václav (1848–1922), sculptor
Náhlovský, Jan (1876–1957), lawyer
Neumann, Alexander (dates unknown), Austrian architect
Nietzsche, Friedrich (1844–1900), German philosopher

Novák, Karel (1871–1955), sculptor

Novotný, Otakar (1880–1959), architect

Ohmann, Friedrich (Bedřich) (1858–1927), Austrian architect

Olbrich, Joseph Maria (1867–1908), Austrian architect

Opatrný, Karel (1881–1961), sculptor

Palacký, František (1798–1876), historian and politician

Pekárek, Josef (1873–1838), sculptor

Peterka, Lev (dates unknown), banker, Prague councillor

Pfeiffer, Antonín (1879–1938), builder

Plečnik, Jože (1872–1957), Slovenian architect

Polívka, Osvald (1859–1931), architect

Popp, Antonín (1850–1915), sculptor

Preisler, Jan (1872–1918), painter

Procházka, Antonín (1849–1903), sculptor

Rodin, Auguste (1840–1917), French sculptor

Roštlapil, Václav (1856–1930), architect

Rous, František (1872–1936), sculptor

Sakař, Josef (1856–1936), architect

Schauer, Hugo Gordon (1862–1892), journalist and literary critic

Schnirch, Bohuslav (1845–1901), sculptor

Schopenhauer, Arthur (1788–1860), German philosopher

Schulz, Josef (1840–1917), architect

Sieburger, Hugo (unknown dates), imperial councillor, factory owner

Stibral, Jiří (1859–1939), architect

Sucharda, Stanislav (1866–1916), sculptor

Sucharda, Vojtěch (1884–1968), sculptor and puppeteer

Šaloun, Ladislav (1870–1946), sculptor

Špillar, Karel (1871–1939), painter

Štapfer, Karel (1863–1930), painter, graphic artist and scenographer

Štenc, Jan (1871–1947), publisher

Štursa, Jan (1880–1925), sculptor

Švabinský, Max (1873–1962), painter and graphic artist

Teschner, Richard (1879–1948), painter and graphic artist

Topič, František (1858–1941), publisher and bookseller

Trmal, František (1866–1945), principal of a business school

Urbánek, Mojmír (1876–1919), music publisher

Vosmík, Čeněk (1860–1944), sculptor

Wagner, Otto (1841–1918), Austrian architect

Waigant, Antonín (1880–1918), sculptor

Waigant, Bohumil (1885–1930), architect

Weichert, Emil (dates unknown), engineer

Wenig, Josef (1885–1939), painter, illustrator and scenographer

Wiehl, Antonín (1846–1910), architect

Wright, Frank Lloyd (1867–1959), American architect and theoretician

Wurzel, Ludvík (1868–1913), sculptor

Zasche, Josef (1871–1957), architect

Zítek, Josef (1832–1909), architect

Ženíšek, František (1849–1916), painter

A MAP OF ART NOUVEAU ART AND ARCHITECTURE IN PRAGUE

1 Municipal House (Obecní dům), náměstí Republiky 5, Prague-Old Town

2 Hotel Central, Hybernská 10, Prague-New Town

3 Twin Apartment Buildings (Dvojdům), U Prašné brány 1 and 3, Celetná 33, Prague-Old Town

4 Land Bank (Zemská banka), Na Příkopě 20, Prague-New Town

5 Bohemian Eagle House (Dům U České orlice), Ovocný trh 15, Celetná 30, Prague-Old Town

6 Black Madonna House (Dům U Černé Matky Boží), Ovocný trh 19, Celetná 34, Prague-Old Town

7 Jan Hus Monument (L. Šaloun), Old Town Square, Prague-Old Town

8 City Insurance Company (Městská pojišťovna), Old Town Square 6, Prague-Old Town

9 New City Hall (Nová radnice), Mariánské náměstí 2, Prague-Old Town

10 Museum of Decorative Arts (Uměleckoprůmyslové muzeum), 17. listopadu 2, Prague-Josefov

11 Engel Villa and apartment buildings for clerks, Břehová 3 and U Starého hřbitova 4, 6, 8 and Břehová 1, Prague-Josefov

12 Moses (F. Bílek), Pařížská Avenue, Prague-Old Town

13 Štenc House, Salvátorská 8 and 10, Prague-Old Town

14 Apartment Buildings in Haštalská 4 and 6, Prague-Old Town

15 Main Railway Station (Hlavní nádraží), Wilsonova 16 and 18, Prague-Vinohrady

16 Grand Hotel Evropa and Hotel Meran, Wenceslas Square 25 and 27, Prague-New Town

17 Ice Palace (Ledový palác), Wenceslas Square 40, Štěpánská 65, Prague-New Town

18 U Nováků Department Store (Obchodní dům U Nováků), Vodičkova 28 and 30, Prague-New Town

19 Prague Credit Bank (Pražská úvěrní banka), 28. října 13, Prague-Old Town

20 The Viennese Bank Association Palace (Dům Vídeňské bankovní jednoty), Na Příkopě 3 and 5, Prague-Old Town

21 The Mozarteum, Jungmannova 30, Prague-New Town

22–23 Insurance Company Praha (Pojišťovna Praha) and Topič House, Národní třída 7 and 9, Prague-Old Town

24 Hilbert House, Masarykovo nábřeží 26, Prague-New Town

25 Hlahol Choir Society Building (Dům spolku Hlahol), Masarykovo nábřeží 16, Vojtěšská 5, Prague-New Town

26 František Palacký Monument (S. Sucharda), Palackého náměstí, Prague-New Town

27 Buildings at the Foot of the Vyšehrad Rock (Villa Na Libušince, Rašínovo nábřeží 26, Libušina 1, and the Kovařovic Villa, Libušina 3, Vyšehrad)

28 Vyšehrad – Slavín and J. V. Myslbek's Sculptural Group

29 Trmal Villa, Vilová 11, Prague-Strašnice

30 Sepulchres by Jan Kotěra in the New Jewish Cemetery, Izraelská 1, Prague-Žižkov

31 Šaloun Studio, Slovenská 2, Prague-Vinohrady

32 Kotěra Villa, Hradešínská 6, Prague-Vinohrady

33 Laichter House, Chopinova 4, Prague-Vinohrady

34 Hanau Pavilion (Hanavský pavilion), Letenské sady, Prague-Holešovice

35 Kramář Villa, Gogolova 1, Prague-Hradčany

36 Bílek Villa, Mickiewiczova 1, Prague-Hradčany

37 Wilfert Villa, Na Špejcharu 3, Prague-Holešovice

38 Koula Villa, Slavíčkova 17, Prague-Bubeneč

39 Sucharda Villa, Slavíčkova 6, Prague-Bubeneč

40 Mašek Villa, Slavíčkova 7, Prague-Bubeneč

41 Náhlovský Villa, Suchardova 4, Prague-Bubeneč

42 Sieburger Villa, Pod Kaštany 18, Prague-Bubeneč

43 Industrial Palace (Průmyslový palác), Exhibition Grounds, Prague-Bubeneč

44 Sewage Treatment Plant (Čistírna odpadních vod), Papírenská 6, Prague-Bubeneč

(P) Peterka House, Wenceslas Square 12, Prague-New Town

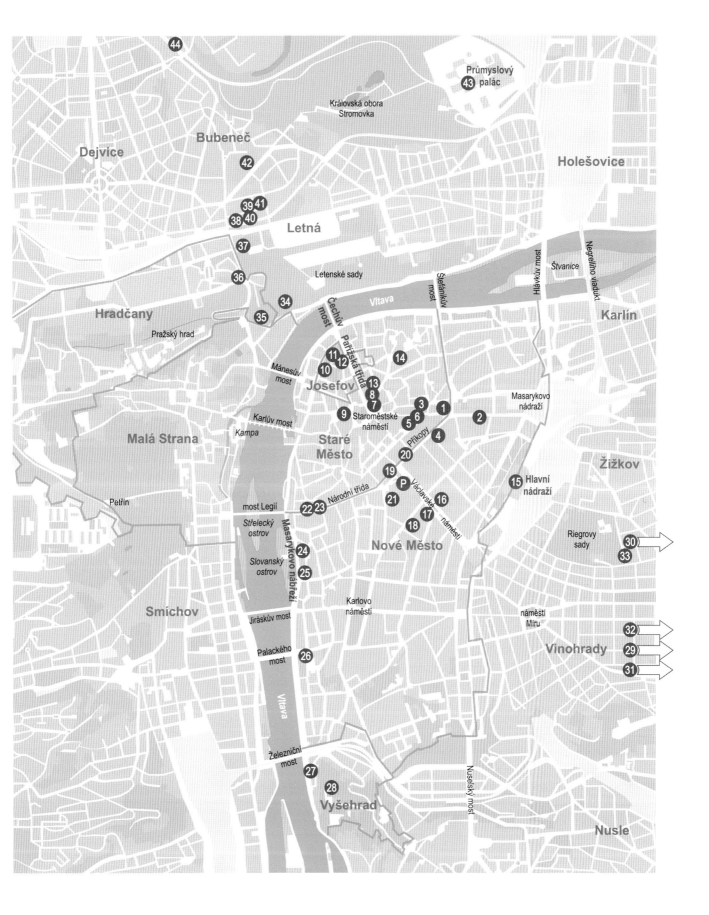

LIST OF ILLUSTRATIONS

Photographs by Věroslav Škrabánek: book jacket, flap, opening pages, fig. nos. 1–10A, 11–49

Book jacket: Detail of the façade of Hotel Central; Municipal House
Flap: Main Station
Opening pages: Municipal House – detail of the roof and dome, Mayor's Hall; Entrance door to an Art Nouveau building in Haštalská Street; Industrial Palace; Mascaron – detail from the Municipal House roof

Documentary photographs

Jan Kotěra: Mánes Association Pavilion, exterior, 1902, author's archive. See, Jan Kotěra. 1871–1923. Zakladatel moderní české architektury [Jan Kotěra. 1871–1923. Founder of Modern Czech Architecture]. Prague: Municipal House/Kant 2001, on p. 122, p. 34

Jan Štursa: Melancholic Girl, 1906, French sandstone, 90 cm, National Gallery Prague, p. 35

Jan Kotěra – Pavel Janák – Josef Gočár – Jan Štursa: Pavilion of Trade and Industry at the Exhibition of the Chamber of Commerce and Trade in Prague, 1907–1908, aerial view. See, Jan Kotěra. 1871–1923. Zakladatel moderní české architektury [Jan Kotěra. 1871–1923. Founder of Modern Czech Architecture]. Prague: Municipal House/Kant 2001, on p. 168, p. 36

Jan Konůpek: Design of a cover for the *Meditace* magazine, 1909, India ink on paper, 49.4 × 37.4 cm, National Gallery Prague, p. 38

Antonín Slavíček: Prague from Letná Park, 1908, tempera on canvas, 185.5 × 390 cm, National Gallery Prague, pp. 40–41

Art Nouveau Prague – An Illustrated Guide to the City

Frontispiece: Municipal House – main façade

1A–U/ The Municipal House in Prague, nám. Republiky 5, Prague-Old Town

2A–C/ Hotel Central, Hybernská 10, Prague-New Town

3/ Twin Apartment Buildings, Celetná 33, U Prašné brány 1 and 3, Prague-Old Town

4A–D/ Land Bank, Na Příkopě 20, Prague-New Town

5A–B/ Bohemian Eagle House, Ovocný trh 15, Celetná 30, Prague-Old Town

6A–C/ Black Madonna House, Ovocný trh 19 and Celetná 34, Prague-Old Town

7A–B/ Jan Hus Monument, Old Town Square, Prague-Old Town

8A–D/ Prague City Insurance Company, Old Town Square 6, Prague-Old Town

9A–C/ New City Hall, Mariánské nám. 2, Prague-Old Town

10A–K/ Museum of Decorative Arts, 17. listopadu 2, Prague-Josefov

 10A/ Museum of Decorative Arts, façade

 10B/ A bowl decorated by stylised butterflies, Anna Boudová-Suchardová, ca. 1900, fired clay, engobe, colourful underglaze, lead glaze, diam. 34 cm, photograph by the Museum of Decorative Arts in Prague

 10C/ Vase, František Soukup, 1904, earthenware, blue glaze, 17.5 cm, photograph by the Museum of Decorative Arts in Prague

 10D/ Small, chalice vase, Pavel Janák, 1911, soft earthenware, white glaze, black lines, 13 cm, photograph by the Museum of Decorative Arts in Prague

 10E/ Vase, Johann Lötz vdova glassworks, Klášterský mlýn, ca. 1902, clear glass with brownish opaline overlays on both sides, hand blown, iridescent, 14.5 cm, photograph by the Museum of Decorative Arts in Prague

 10F/ Vase, Elisabeth, Pallme-König & Habel, Košťany u Teplic, ca 1902, green glass, hand blown, 9.5 cm, photograph by the Museum of Decorative Arts in Prague

 10G/ Box of chocolates, Karel Ebner, 1909, silver, partly gilded, mother-of-pearl, coral, moonstone, turquoise, w. 6.5 cm

 10H/ Brooch, Josef Ladislav Němec, after 1900, gilded silver, mother-of-pearl, carnelian, 5.5 cm, photograph by the Museum of Decorative Arts in Prague

 10I/ Candlestick, Emanuel Novák Studio, 1908, poured brass, 20 cm, photograph by the Museum of Decorative Arts in Prague

 10J/ Chair from the interior of the School of Decorative Arts in Prague at the Paris World's Fair in 1900, Jan Kastner, 1899, oak and walnut wood, cut, polychromed, 92 cm, photograph by the Museum of Decorative Arts in Prague

 10K/ Armchair from Jan Laichter's dining room, Jan Kotěra, 1907–1908, oak, leather, copper, 77.5 cm, photograph by the Museum of Decorative Arts in Prague

11A–C/ Engel Villa and Apartment Building for Clerks, Břehová 3, Prague-Josefov; U Starého hřbitova 4, 6 and 8, Břehová 1

12/ František Bílek: Moses, Pařížská Avenue, Prague-Old Town

13/ Pařížská Avenue, Prague-Old Town

14A–B/ Štenc House, Salvátorská 8 and 10, Prague-Old Town

15A–C/ Apartment Buildings, Haštalská 4 and 6, Prague-Old Town

16A–C/ Main Railway Station, Wilsonova 16 and 18, Prague-Vinohrady

17A–C/ Grand Hotel Evropa and Hotel Meran, Wenceslas Square 25 and 27, Prague-New Town

18A–B/ Ice Palace, Wenceslas Square 40, Prague-New Town

19A–B/ U Nováků Department Store, Vodičkova 28 and 30, Prague-New Town

20A–C/ Prague Credit Bank, 28. října 13, Prague-Old Town

21A–B/ The Viennese Bank Association Palace, Na Příkopě 3 and 5, Prague-Old Town

22A–C/ The Mozarteum (Urbánek House), Jungmannova 30, Prague-New Town

23A–B/ Insurance Company Praha, Národní třída 7, Prague-Old Town

24/ Topič House, Národní třída 9, Prague-Old Town

25/ Apartment Buildings on Masaryk Embankment, Prague-New Town

26A–C/ Hilbert House, Masarykovo nábřeží 26, Prague-New Town

27A–B/ Hlahol Choir Society Building, Masarykovo nábřeží 16, Vojtěšská 5, Prague-New Town

28A–C/ František Palacký Monument, Palackého náměstí, Prague-New Town

29A–B/ Buildings at the Foot of the Vyšehrad Rock:

 29A/ Villa Na Libušince, Rašínovo nábřeží 26, Libušina 1, Prague-Vyšehrad

 29B/ Kovařovič Villa, Libušina 3, Prague-Vyšehrad

30A–E/ Vyšehrad – Slavín and Josef Václav Myslbek's Sculptural Groups: Libuše and Přemysl, Ctirad and Šárka, Záboj and Slavoj

31/ Trmal Villa, Vilová 11, Prague-Strašnice

32A–B/ Sepulchres by Jan Kotěra in the New Jewish Cemetery, Izraelská 1, Prague-Žižkov

33A–B/ Šaloun Studio, Slovenská 2, Prague-Vinohrady

34/ Kotěra Villa, Hradešínská 6, Prague-Vinohrady

35A–B/ Laichter House, Chopinova 4, Prague-Vinohrady

36A–B/ Svatopluk Čech Bridge

37/ Hanau Pavillion, Letenské sady, Prague-Holešovice

38/ Kramář Villa, Gogolova 1, Prague-Hradčany

39A–F/ Bílek Villa, Mickiewiczova 1, Prague-Hradčany

40A–B/ Wilfert Villa, Na Špejcharu 3, Prague-Holešovice

41/ Koula Villa, Slavíčkova 17, Prague-Bubeneč

42A–B/ Sucharda Villa, Slavíčkova 6, Prague-Bubeneč

43/ Mašek Villa, Slavíčkova 7, Prague-Bubeneč

44/ Náhlovský Villa, Suchardova 4, Prague-Bubeneč

45/ Sieburger Villa, Pod Kaštany 18, Prague-Bubeneč

46A–B/ Industrial Palace, Exhibition Grounds, Prague-Bubeneč

47A–B/ Sewage Treatment Plant, Papírenská 6, Prague-Bubeneč

ACKNOWLEDGEMENTS

Karolinum Press would like to thank the administrators
of artistic and historical collections for kindly providing images
for this book and for their consent to reproduce them.

Prof. PhDr. PETR WITTLICH, CSc. (1932)

A graduate in art history from the Faculty of Arts, Charles University (CUFA), where he worked as a senior lecturer (from 1959), associate professor (from 1990) and professor (from 1992). Between 1992 and 2000, he was head of the Institute of Art History, CUFA. In 1990, he became head of the Czechoslovak section of the International Association of Art Critics (AICA) and the Art History Association in the Czech lands. His contributions to the knowledge of Czech art at the turn of the 20th century and during the interwar period, which he chose as his main theme, are pre-eminent. As an expert on the Czech Art Nouveau style, he has gained respect in the European context. He has contributed to many Czech and foreign journals, participated in many exhibitions, while his monographs have been translated into many languages. He received the František Palacký Medal, a silver medal awarded by CUFA, and a gold medal awarded by Charles University. In 2012, he won the Ministry of Culture Award for Contribution to the Fine Arts and received the Medal of Merit in Art and Culture.

Exhibitions (a selection)
Situace 92. Prague, Mánes, 1992
Alfons Mucha. Prague, Pražský hrad, 1994
Jan Preisler. Putování krajinami duše [Travelling Through the Landscapes of the Soul]. Pilsen, Gallery of West Bohemia, 1994
Alfons Mucha. Triumph des Jugendstils. Hamburg, Museum für Kunst und Gewerbe, 1997
Alphonse Mucha and the Spirit of Art Nouveau. Lisbon, Calouste Gulbenkian Museum, 1997
Důvěrný prostor – nová dálka. Umění pražské secese [Familiar Space – New Distance. Prague's Art Nouveau]. Prague, Municipal House, 1997
Prague Art Nouveau. Métamorphoses d'un style. Bruxelles, Palais des Beaux-Arts, 1998
Prague 1900. Poetry and Ecstasy. Amsterdam, Van Gogh Museum, 1999
Sochař Ladislav Šaloun [Sculptor Ladislav Šaloun]. Prague, Lobkowicz Palace, 2000
František Bílek. Paris, Musée Bourdelle, 2002
Jan Preisler. 1872–1918. Prague, Obecní dům, 2003
Neklidná figura. Exprese v českém sochařství 1880–1914 [The Restless Figure. Expression in Czech Sculpture 1880–1914]. Prague, Prague City Gallery, 2016
Ellen Jilemnická. Prague, Topičův salon, 2017

Publications (a selection)
Kresby Jana Štursy [Jan Štursa's Drawings]. Prague: Nakladatelství čs. výtvarných umělců, 1959
Art Nouveau 1900. Paris: Gründ, 1975
Art Nouveau Drawings. London: Octopus Books, 1974, 1975; Prague: Artia, 1976

České sochařství ve XX. století. 1890–1945 [Czech Sculpture in the 20th Century. 1890–1945]. Prague: SPN, 1978

Česká secese [Czech Art Nouveau]. Prague: Odeon, 1982, 1985

Edvard Munch. Prague: Odeon, 1985; Stockholm: Bokförlagen Prisma, 1987

Umění a život – doba secese [Art and Life – Art Nouveau Period]. Prague: Artia, 1986

Jan Preisler. Kresby [Jan Preisler. Drawings]. Prague: Odeon, 1988

Art Nouveau. Pintura, granado, excultura, arquitectura, artes aplicadas. Madrid: Editorial Libsa, 1990

Art Noveau. Pittura – oreficeria – soprammobili – sculura – architektura. La Spezia: Fratelli Neplita, 1990

Prague Fin de siecle. Paris: Flammarion, 1992; New York: Abberville, 1992; Köln: Taschen Verlag, 1999

Sochařství české secese [Czech Art Nouveau Sculpture]. Prague: Karolinum Press, 2000; *Die Bildauerkunst der Tschechischen Sezession*, 2001; *Sculpture of the Czech Art Nouveau*, 2001

Secesní Prahou – Podoby stylu [Art Nouveau Prague – Forms of the Style]. Prague: Karolinum Press, 2005; *Prag im Jugendstil – Ein Stil in seinen Formen*, 2007; *Art Nouveau Prague – Forms of the Style*, 2007, 2009, 2011

Jan Štursa. Prague: Academia, 2008

Horizonty umění [Horizons of Art]. Prague: Karolinum Press, 2010

Secesní malířství [Art Nouveau Painting]. Prague: Karolinum Press, 2012; *Czech Modern Painters,* 2012

Bohumil Kafka. Příběh sochaře [Bohumil Kafka. A Story of a Sculptor]. Prague: Karolinum Press, 2014